reactionary as a determining
reason foundation within activity.

Absorbtion of initially reactionary work into
the system — its prolifigation and final
death through acceptance. INERTIA.

knowing reactionism — Absorbtion — Calcifica
volitile potential. Acceptance Inerti

Wittgenstein. Tract. 6.54. 'My propositions serv
as elucidations in the following way; anyone who
understands me eventually recognises them as
nonsensical, when he as used them — as steps.
to climb up beyond them. (He must, so to spea
throw away the ladder after he has climbed
it) He must transcend these propositions, a
then he will see the world aright.'

Palpitable reactionism —

If the system 'Accepts' the work by recognit
nd accepts it on account of its being reactio
hen it is in fact proving that it is not at
reactionary. A truly reactionary stance
gainst an existing system cannot poss

P9-DBW-673

MARION
MARCH

CREATIVE

TYPOGRAPHY

!

CREATIVE TYPOGRAPHY

MARION MARCH

NORTH LIGHT BOOKS

Cincinnati, Ohio

MARION
MARCH

CREATIVE
TYPOGRAPHY

!

NORTH
LIGHT
BOOKS

Cincinnati, Ohio

A QUARTO BOOK

First published in the U.S.A. by
North Light Books, an imprint of
F & W Publications, Inc.
1507 Dana Avenue
Cincinnati, Ohio 45207

Copyright © 1988 Quarto Publishing plc

ISBN 0-89134-258-3

All rights reserved
No part of this book may be reproduced in any form
or by any means without permission from the
Publisher

This book was designed and produced by
Quarto Publishing plc
The Old Brewery, 6 Blundell Street
London N7 9BH

Senior Editor Maria Pal

Editors Joy Law, Mary Senechal

Designer Julia King

Picture Researcher Joanne King

Art Director Moira Clinch
Editorial Director Carolyn King

Typeset by Burbeck Associates Ltd, Harlow
Manufactured in Hong Kong by
Regent Publishing Services Ltd
Printed in Hong Kong by South Sea Int'l Press Ltd.

Special thanks to Steve Hollingshead and
Christine Barrow

CONTENTS

PART 1
INTRODUCTION

PART

1.

INTRODUCTION

What is creative typography?

Creative typography is a broad term that can mean different things to different people. All graphic designers have their own idea of what they would call the creative use of type. Some would cite emotive renditions of poetry in bizarre formats, others would point to complex information which is handled in an elegant and classical manner — both would be correct.

In some cases all typography can be called creative; no design problem can be resolved by running on "automatic pilot," and even the most humdrum job is the better for imaginative treatment. There are no absolute definitions either of what it is or of what it should be.

Consequently the idea of being creative with type can be daunting not only for beginners or students of graphic design, but also for professionals on whom there is constant pressure for originality and novelty in fields as disparate as record sleeves or company reports.

So how do we prime our creativity?

Even though we realize that there are no hard and fast rules, and that there are as many differences of opinion as there are practitioners of the subject, to get us started we shall proceed by outlining some basic assumptions and then start shading in the values in between.

So, for practical purposes we shall say that creative typography is:

using type or lettering, either on its own or with other graphic elements, to convey information or an idea in the most effective way we can, given the limitations imposed on us by time, money or technical considerations.

In Part One, we will consider ways in which we can use our everyday surroundings and our personal interests to increase our perceptions; in Part Two we will explore some of the specific typographic means by which we can enlarge our creative vocabulary and build up an individual "toolkit" that is always to hand.

Part Three consists of a series of basic projects which examine the relationship between Type and Lettering, Type and Color, Type and Image. Each project or exercise is structured to help develop our sensitivity to letterforms and the words or statements made up from them; and, in so doing, to stimulate our imagination. "Basic" does not necessarily mean simple or for beginners only; most of them are well tried "classics," used by many professionals to get them started when they are out of ideas.

All the exercises given deal with the most common problems encountered when having to tackle a professional brief or job. They have been chosen to demonstrate the most creative approach to meeting the demands of the most exacting commercial clients, while at the same time giving you the opportunity to enjoy the discovery of your individual responses which will, as time goes on, grow into a style which is unique to you.

though that before you can bend such rules as there are, you need to know what they are.

Here are some examples of the creative use of type designed by both students and professionals seeking to solve a wide variety of problems.

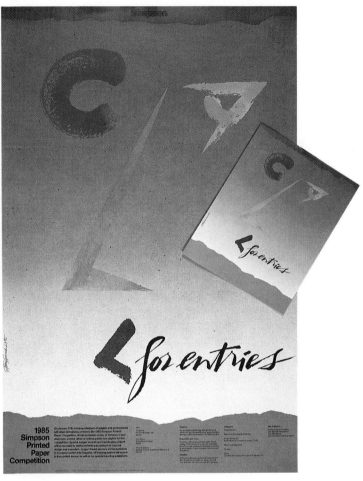

■ **Above** The creative spirit embodied in the stroke of a letter. Symbol for the Madrid Artists' Association, 1977.

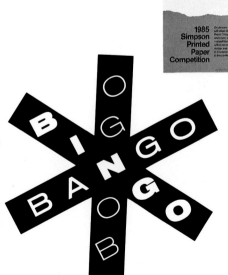

■ **Right** Logotype for a Japanese disco, Bingo Bango Bongo, designed by Peter Saville and Associates. An unusual layout and different weights of typeface live up to the hectic quality of an extraordinary name.

■ **Above** Brush-stroke letters become a face in this "Call for Entries" poster by Tim Girvin Design Inc. of Seattle, Washington; created as part of a national campaign for the Simpson Paper Company. A select group of designers were invited to design a poster to be sent to design firms and agencies throughout the US, as well as being used for national advertising.

Right Poster for London's National Theatre production of *Waiting for Godot* by Samuel Beckett; designed by Richard Bird and Associates. Colorful type plays the central role in a design that conveys a surreal atmosphere.

Below Letters come alive in a sign indicating men's and women's toilets; located in the Michael Peters Design Office in London. Designed by Fernando Medina of Montreal, Canada.

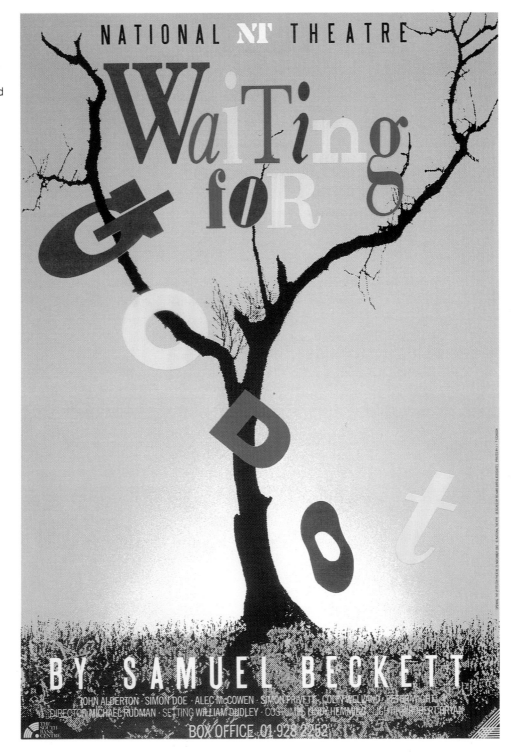

Learn to look around you

The first step to thinking creatively about type has nothing to do with studio skills or techniques; it is a matter of mental attitude and the acquisition of a well-stocked mind.

Today, more than ever before, we are bombarded with a ceaseless flow of words and images. We cannot but be influenced by the messages they are designed to convey nor unaffected by the visual experiences they create. Although the media-generated environment is referred to by its detractors as "sensory pollution," we should be able to sift out for ourselves the good from the bad and be responsive to material that we can turn to our own advantage. We need to build our own set of usable reference data.

To do this we must expose ourselves to as many different sources of graphic imagery as we can. Not only should we go out of our way to visit exhibitions and read the professional journals, but just as important, we should train ourselves to look at every form of graphic display, be it in stores, on billboards, in newspapers, magazines or books, and make a conscious and critical assessment of what we see. Get into the habit of traveling with pencil and paper and make a note or sketch of anything that takes your fancy or gives you food for thought.

Be imaginative about external stimulus and you will be well repaid when you demand internal stimulus to come to your aid on a design task. Consider, for example, the whole new world that

Here are some examples of the use of type in our environment — aiming to inform as well as entertain us.

exists above eye-level in any townscape. Look up and observe it all, from the architectural or purely graphic detail to such seeming irrelevancies as a pair of lace curtains, and you will soon acquire a valuable collection of unusual images.

At the other end of the scale you could start examining any household product that carries graphics. Look at the logo on the bag, the artwork on the tube of toothpaste or the packet of cheese and consider the corn as you crunch your cornflakes.

Looking at and thinking about the way other designers have conveyed their message makes you consider how *you* would like to have dealt with it.

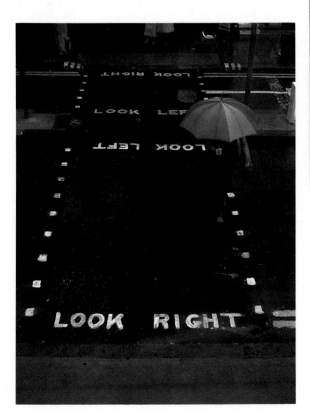

VISUAL RESEARCH Not only should you make notes or sketches of what you see; start a loose-leaf scrapbook with cuttings filed under topics or themes. You are creating an ideas bank; **and keep on learning to look around you!**

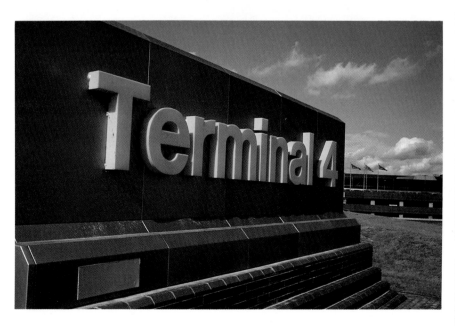

PART 2 LANGUAGE OF TYPE

PART

2.

LANGUAGE OF TYPE

Building a visual vocabulary

And now, more specifically, to *type*. In order to communicate ideas visually you need a set of basic tools with which you become more and more proficient. It is comforting to know that you can build up a creative "toolkit" whose components, tried and tested, will always be to hand. As with all toolkits, you can constantly increase both the quantity and the quality of its contents.

Your first requirement is an understanding of the differences between typefaces and the different look they take on when printed in different ways. Some type is thin, some is **thick**; some will read better on matte than on shiny paper, and *vice versa*. Get to learn these differences and appreciate the individual characteristics of as many typefaces as you can.

Familiarize yourself with the different qualities of paper, or card. Experiment with reversing out, or distorting, doodling, use any device you can to increase your own personal typographic vocabulary. Learn how to express your own feelings so that you begin to develop your own style.

Self-awareness is another vital tool, since typography is neither an automatic nor mechanical process nor generated by magic. It is an activity produced by thought, imagination and skill, and its degree of creativity depends on the personal attitude of the designer, so make sure that you know what your own attitude to any job is, or is likely to be.

While the first task of the designer is to convey information or pass on a message, and to do so accurately and clearly, a personal view about the form and content is equally important. This is one of the reasons why visual research (see page 12) can be

■ **Right** Alphabets are a never-ending source of fun and experimentation. The sequence of characters shown here is part of an alphabet created by Christine Barrow, using cut-up magazines, photocopies, scrap paper, type, and other bits of this and that…Personal projects such as this are a wonderful way of developing a love of letterforms and type — and who needs expensive materials and equipment?

so valuable in broadening our attitudes as well as building up a reserve of visual images seen and felt by other designers.

Lest this sounds overly academic and smacks of discipline, remember that you cannot break the rules until you know what they are. It is fun, and necessary in any activity, to stretch, bend or break even the loosest of generalizations, and typography is no exception. It is often thought that companies' annual reports should be typeset in uniform, mechanical-looking typefaces (a generalization rather than a rule) because they are "suitable" for corporate work. But there is no reason why you shouldn't use a more decorative typeface to create personality in even the most dauntingly dense copy, nor, by the same token, why you shouldn't be able to

achieve a more emotional response by using a core sans serif type. You achieve the results you want by knowing what it is you want, and by having the skill to achieve your desire.

■ **Above** This spread from the 1986 Holland Festival leaflet, designed by Studio Dumbar, shows playfully drawn letterforms within a commercial job.

The personality of a typeface

Let us look more closely at the characteristics of typefaces which differentiate them. After all each one has been produced by a designer who has given it a personality to convey messages in a particular tone. Types with serifs are quite different from sans serifs; heavily ornamented letters fulfill a different function from a delicately slanted script. While it is often assumed that sans serifs are particularly suitable for such tasks as annual reports to give them an air of technical efficiency to reflect the company's performance and success, it is not until you have taken in the differences between types that you can judge if this is necessarily true. Moreover, as we shall see, you can, by your graphic treatment of a typeface, alter its character. You must, though, take into account the personality of the type in judging its suitability for the task in hand.

Commercial

Eurostile

New

Benguiat Gothic

ROCKWELL

SHADOW

PEIGNOT

Franklin

Univers 45

Goudy

Europa Grotesk

Newtext

Cooper Black

Folio

Bodoni

American Typewriter

ENGRAVERS

COPPERPLATE

News Gothic

Gill Sans

Clearface Gothic

Garamond

Kabel

Baskerville

Fenice

Ehrhard **Congress**

Gothic Cushing

Times

Old Style

Compacta

■ **Below** Poster designed by Minoru Morita of the Creative Center, NYC, to publicize an exhibition of his work in a Tokyo gallery, 1975. A variety of different typefaces is used to represent the melting-pot of people and stimulating chaos of sight and sound that we all know as New York City.

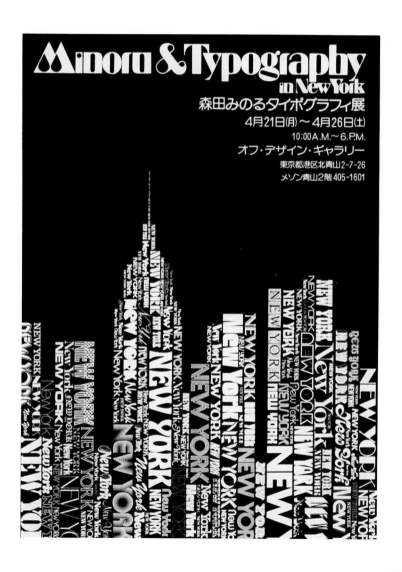

When comparing one typeface with another, notice that letters can vary not only in their design (like **c** and **c**), but also in their actual form (**g** and **g**, **a** and **a**). This could prove to be a useful design tool.

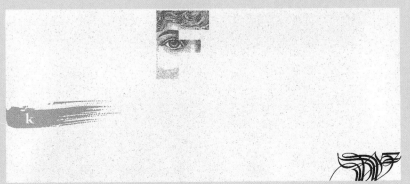

■ **Above and left** Stationery for
The Kentucky Foundation for
Women, by Images design studio
of Louisville, Kentucky. Each of
the letterforms "KFW" is given a
different personality every time it
appears. Some of the characters
are simple and bold, others are
rich with detail — but all in all, it's a
marvelous way to symbolize the
varied qualities of women. The
effect is particularly striking when
a number of items in the range are
seen together.

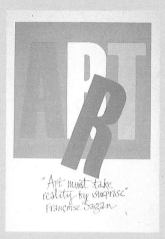

"Art must take reality by surprise"
Françoise Sagan

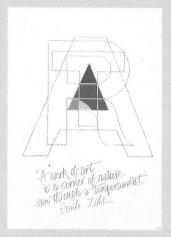

"A work of art is a corner of nature seen through a temperament"
Emile Zola

■ **Below** A series of six posters, all based on the word "ART," by Alan Fletcher of Pentagram for IBM Europe. The posters were created in 1983 to enliven the walls of IBM Europe's new headquarters in Tour Pascal, Paris, and to act as a holding device while waiting for a collection of prints and paintings to arrive and take their place in the new offices. Different quotations from writers and artists are interpreted through the use of type, lettering, and handwriting in a colorful and lively sequence.

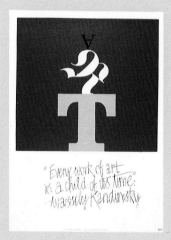

"Every work of art is a child of its time."
Wassily Kandinsky

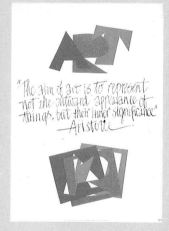

"The aim of art is to represent not the outward appearance of things, but their inner significance."
Aristotle

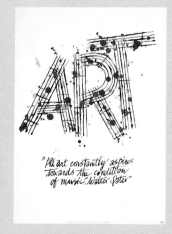

"All art constantly aspires towards the condition of music. Walter Pater

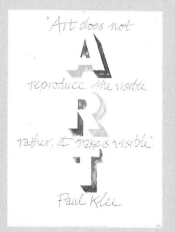

"Art does not reproduce the visible rather, it makes visible."
Paul Klee

Fonts and families

■ **Below** Book cover and two spreads from *The Bald Soprano,* a play by Eugene Ionesco, with typographic interpretations by Massin and photographs by Henry Cohen (1965 edition). This popular graphic interpretation of Ionesco's play uses different characters from the play, and other interesting visual devices — such as changing the style and size of type to show a change in the tone of voice. It's a classic, and a feast for the eyes.

A type *font* consists of all the characters in one size of a typeface. This usually includes capitals — "caps" or upper case; lower case; numerals; and punctuation marks. A matrix will contain all these characters in any given size of typeface. It represents all the letter-forms in that particular size and face. They vary from font to font and size to size, so have a good look at what is available before choosing one. Some, for example, will have SMALL CAPS; in some the numerals will range — that is have a uniform x-height.

A typeface *family,* on the other hand, is a group or range of faces which are all variations of one particular typeface design. A family consists of variations such as roman, italic, light, medium, bold, condensed and expanded. Although all stem from one design, each version will project its own particular atmosphere and tone — a bit like hearing different voices within one choir. Although you can have fun testing your creativity by restricting yourself to one font or one family, do not allow this to become a strait jacket. Consider the exciting possibilities, for example, of using different type-faces to identify the different characters in a play.

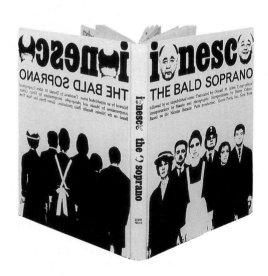

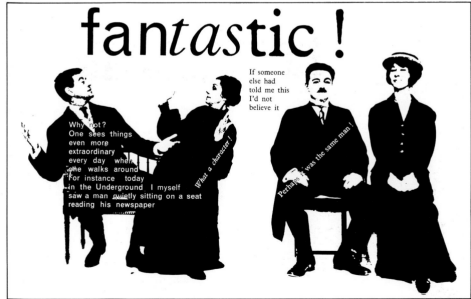

■ **Left** A logotype by Jurek Wajdowicz of New York City skillfully combines numerals and words. As this example shows, it's important to remember that there is more to a font than letters!

These are the most common of the characters that are included in most fonts of type:

Capitals or Caps (Upper case)
Small caps
Lower case
Ligatures fi, ff, fl, ffi, ffl
Numerals or Figures
Punctuation
Miscellaneous signs, eg.
 [Brackets]
 (Parentheses)
 Ampersand &
 Currency signs £ $
 Oblique or Slash /
Diphthongs æ, œ
Reference marks, eg.
 * Asterisk
 † Dagger
 ‡ Double dagger
 ¶ Paragraph
Accents é ô ñ
Fractions ¼ ⅓ ⅛ ⅝
Braces ⎰⎱
Leaders
Mathematical signs ÷ > = <
Commercial signs eg. @, %

Before you start, check what is already in the font. If it does not contain what you need, choose another one, or if you are after an unusual character you may have to draw it and have it incorporated in the font. Check that option with your typesetter.

Playing with size

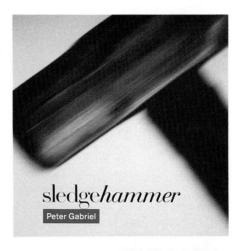

Another basic tool is an understanding of the effects that can be achieved by the size of the type you choose. It is obvious that LARGE type shouts and minute type whispers. Changes in type size can, on the other hand, be purely functional, as for example when they are used to make clear headings or subsidiary matter in a textbook.

Suitability also plays its part; since a book exists to be read, legibility is of paramount importance; the type must be large enough to be read easily but not so large that it gets in the way. You can be more adventurous with display work — book jackets or posters — where mixing sizes, like mixing typefaces, can achieve dramatic and arresting results.

■ **Below** An invitation, designed by Frans Lieshout, to an anniversary exhibition of work by the Amsterdam-based studio, Total Design (1983). The large initials "TD" provide a stable mass around which thin lines, text and headlines buzz excitedly. The off-beat effect is accentuated by the oddly-shaped format.

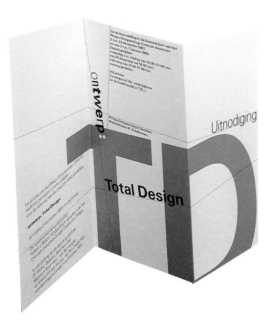

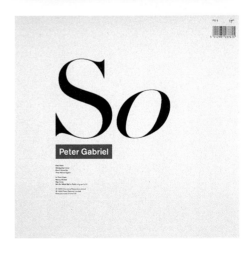

■ **Right** Sleeves for Peter Gabriel's *So* album and *Sledgehammer* 12-inch single. Both were designed by Peter Saville and Associates, with a consistent visual image of simplicity and style. The *So* album sleeve carries a photo of Gabriel on the front (center), and a large "So" on the back (bottom). The *Sledgehammer* sleeve (top) bears a sledgehammer in motion, and one particularly slick feature: the typographic treatment of the title reflects the rhythmic stress that occurs when the word is sung. There's not a lot to it really — but what *is* there is very sensitively handled and that's what counts.

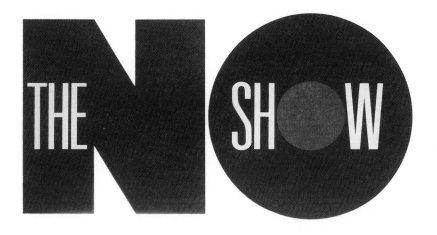

A COMPILATION OF REJECTED CONCEPTS, COMPS AND IDEAS COPYRIGHT 1985 GREGORY CUTSHAW 2210 EMERSON AVENUE DAYTON, OHIO 45406

■ **Left** "The No show" poster designed by Gregory Cutshaw of Dayton, Ohio, 1985. The title pops out of a huge black "NO" that is surrounded by masses of white space. The effect is bright and bouncy, certain to grab even the most distant viewer. The copyline at the bottom reads, "A compilation of rejected concepts, comps and ideas," and we can only presume that the show itself was as much fun as the poster that promoted it.

Arrangement of text

Lengthy text intended for continuous reading needs to be made as accessible as possible, and is, for reasons of maximum legibility, usually typeset in columns of uniform width and depth. The columns can be justified — that is, ranged both left and right, or ranged left with a ragged right-hand side, both of which give the eye a point of return to which it rapidly becomes accustomed.

Smaller amounts of text, like captions or labels, and display copy, titles or headlines, can be treated far more freely, offering greater scope for creativity. They can be centered, ranged right, turned into a shape of their own, or, thanks to the new technology, distorted by special lenses and made to fit a tightly controlled shape.

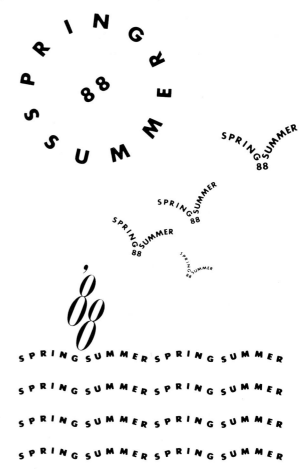

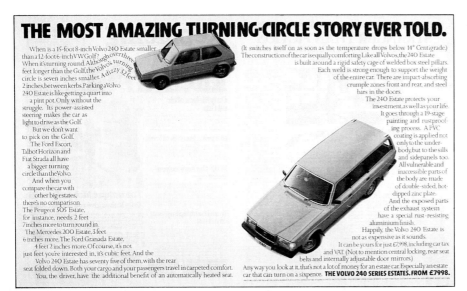

THE MOST AMAZING TURNING-CIRCLE STORY EVER TOLD.

■ **Left** This magazine ad attracts attention through its use of type to define a circular shape — a clever way of drawing the reader to a large piece of text that might otherwise have been ignored. Created by agency Abbott Mead Vickers/SMS for Volvo Concessionaires.

■ **Above** Identity for the Spring/Summer '88 fashion season, designed for Courtaulds Fabrics by Autograph Design Partnership, London. A summery, breezy feeling produced purely through the arrangement of type (which shows that color isn't everything!).

"Ranged left" type arrangement

"Centered" type arrangement

"Ranged right" type arrangement

■ **Below** A centered type arrangement and delicate use of caps provide a classic, literary pose for text that is in fact out to pull a laugh. Poster produced for The Society of West End Theatres by Saatchi & Saatchi, 1985.

Up.
That's the
trend of the Daily
Mail's circulation and
readership. And when you look
at specialist categories, readership is
up by 28% – almost 4 times
the Fleet Street average.
Look at investors who
have accounts in Building
Societies. The Fleet Street
average increase is 8·4%.
The increase in Daily Mail
readers who have Building
Society accounts is 30·7%.
Look at the readers who
have opened new Building
Society accounts in the
last 12 months. The Fleet
Street average increase is
21·7%. The increase in Daily
Mail readers who've opened
new accounts is 42·9%.
Look at the readers who
have Bank Accounts. The
Fleet Street average is
down by 0·2%. Daily Mail
readers with Bank Accounts
are up by over 17%.
Look at Bank Cheque
Card holders. The average
Fleet Street increase is
16·7%. The increase in Daily
Mail readers with Cheque
Cards is 40·3%.
And look at Credit Card
holders. The average Fleet
Street increase is 16·3%. The
increase in Daily Mail read-
ers with Credit Cards is 41%.
To make your advertis-
ing talk to all these affluent
new readers, talk first to
Bruce Olley on 01-353 6000.

Daily Mail

Up.
But by only
a quarter of the
Daily Mail trend. That's
the story for the rest of Fleet
Street as the dynamic Daily Mail just
grows and grows and grows.
So before you even think
about reaching affluent new
readers through any other
daily newspaper talk to
Bruce Olley on 01-353 6000.

The Rest.

IN SHAFTESBURY AVE.
LAST FRIDAY NIGHT,
THERE WERE
9 MURDERS, 13 FIGHTS,
3 SUICIDES,
6 NAKED WOMEN,
1 TORTURE, 40 THIEVES,
PETER PAN
AND SEVERAL FAIRIES.

THE LONDON THEATRE. ACT ON IT

■ **Above** Two illustrations from a booklet intended to promote a photographic service, offered by Conways Photosetting, which can enlarge, distort, stretch, and bend images. Designed by Colin Forbes of Pentagram.

■ **Above** A press ad created by Saatchi & Saatchi for *The Daily Mail* newspaper. Type is set in the shape of arrows, which boast a rise in *The Daily Mail* circulation figures and show it to be clearly ahead of its competitors.

Creative use of space and format

Space and format are the next considerations. You have to take into account both, along with the spatial characteristics of different typefaces. There is the space taken up by the letter itself and the space created within and around it. You can quickly see what these spaces produce by looking at a letter printed in black and white and reversing it out so that the letter reads in white on a black background. It will alter again if you use a tint or a pattern instead of a solid for either the letter or the space. Pay attention, too, to the counters and the strokes of each letterform. An isolated word or letter surrounded by a lot of space will gain in significance whereas crowding will tend to cause words to compete with each other, though that is all right if it achieves the effect you want. L e t t e r s p a c i n g and interlinear spacing are also important design elements.

The choice of format, that is the shape and size of the material on which the type is to appear can also be used to enhance or clarify the message. Long and narrow formats differ from short and wide ones in

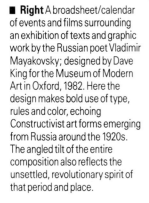

■ **Right** A broadsheet/calendar of events and films surrounding an exhibition of texts and graphic work by the Russian poet Vladimir Mayakovsky; designed by Dave King for the Museum of Modern Art in Oxford, 1982. Here the design makes bold use of type, rules and color, echoing Constructivist art forms emerging from Russia around the 1920s. The angled tilt of the entire composition also reflects the unsettled, revolutionary spirit of that period and place.

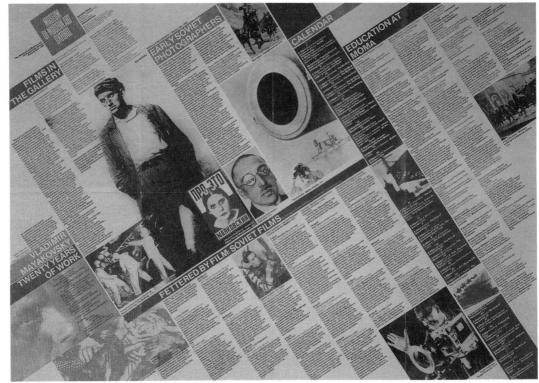

the same way that people of different shapes give different impressions, and the position of the type within a given format can totally alter its character.

Consider what changes occur if the message in the text is confined to the center of a large page, or is placed, say, in the top left-hand corner, or is allowed to run right to all four edges, or even fall off. The type can be placed vertically, horizontally or in a haphazard arrangement. Try it out in these different ways and analyze for yourself the changes that occur.

■ **Below** Promotional fold-out and news sheet for a printing and publishing firm; designed by Hans Arnold for Gavin Martin, 1987. A swirling concoction of typographic fun, using an assortment of typefaces, sizes, and text arrangements. Stumbling around the information is part of the fun, and allows the reader to notice and enjoy the crazy typographic details (such as a passage of text where the letter "o" expands and shrinks every time it appears in a word).

Some women are too embarrassed to have a cervical smear test.

Last year 2,000 women died of embarrassment.

Cancer of the neck of the womb is a completely preventable disease.

If you have a cervical smear every five years your doctor can spot abnormal cells long before they turn into cancer.

And long before you feel any symptoms.

For most women the test is just a precaution. Even if there is something wrong the abnormal cells can simply be removed.

You won't even have to go into hospital.

But if a cancer is allowed to develop you could die. The vast majority of the women who are killed by cervical cancer are over 40.

So if you are in your late thirties or older and are not already having regular smears you should start immediately.

A cervical smear is a quick, painless and safe test. Cervical cancer is a slow, painful way to die. Which would you rather have?

Your nearest clinic with female doctors is

Or ask your own doctor for a cervical smear.

— SOUTH WEST THAMES REGIONAL CANCER ORGANISATION —

■ **Above** An ad appearing in consumer magazines, created by Saatchi & Saatchi for Britain's Health Education Council. Here the use of masses of space to isolate one word presents us with a serious, "think about it" tone. This approach is particularly effective in catching the reader's attention when set within the visual chaos that often occurs in this type of magazine.

Language characteristics

Visual communication with type is dealing with the ideas or concepts that are created by putting together what starts as an abstract shape — the letterform itself — into a pattern (the word), which thereby acquires a meaning. A series of conventions about how to treat both single words and text has grown up but close attention to language leads us to contemplate the effects that can be achieved by disregarding those conventions. For example, setting proper names without opening capitals or continuous text in capitals throughout. Paragraphs may begin with a dropped capital or SMALL CAPS or some other device to indicate a new start.

Letters can be placed backward, upside down, or omitted altogether. See how many letters, or even words, can be dispensed with before the sentence fails to put its meaning across. Reading from left to right isn't sacred; words can be read vertically, or upside down, or even, in some cases, backward. But to make any of these graphic devices succeed we need to be constantly aware of the inherent properties of language itself.

■ **Right** A press ad for British Airways announcing the opening of Terminal 4 at London Airport which states in small type, "You'll miss the Q's when you fly through Terminal 4" (an appealing thought to all who hate standing in line at airports). This example shows how use of language (in this case extracting the letters) can attract attention and curiosity. Created by Saatchi & Saatchi for British Airways.

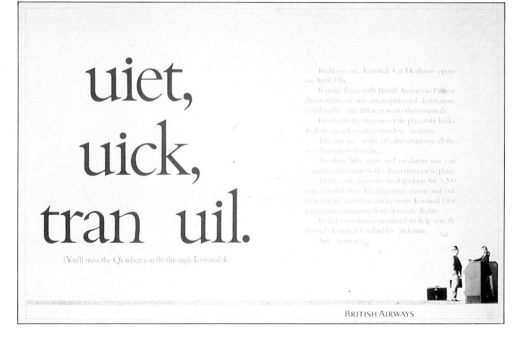

■ **Above** Mervyn Kurlansky of Pentagram designed this poster announcing the 1982 Graphic Design Workshop, an annual course held in England and convened by Kent State University/Ohio and Pentagram. The design is constructed from the title of the course, presented as a pattern of isolated letters. The intrigue lies in the process of reading it!

■ **Below** The use of decorated initials (letters), atmospheric photography and subdued text-type surrounded by oceans of white space creates a sophisticated image of academic quality and tradition in this brochure for The Selwyn School, designed by Sullivan Perkins studio in Dallas, Texas.

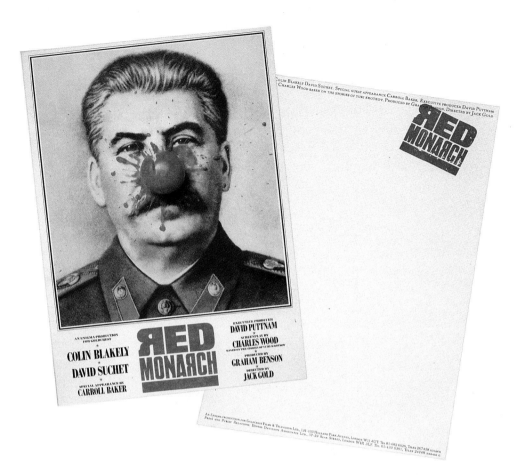

Left Poster for the movie *Red Monarch* (a black comedy about the final years of Stalin's life) and a letterhead for promotional purposes, designed by Howard Brown and John Gorham for Goldcrest Films. The reversed "R" in the title provides a subtle suggestion of the Cyrillic alphabet used in the Russian language.

Right An advertisement that relies on our noticing missing letters of the alphabet, thereby suggesting the motto of the *Financial Times* promotional campaign…"No FT, No Comment." Created by Ogilvy & Mather for the *Financial Times* newspaper.

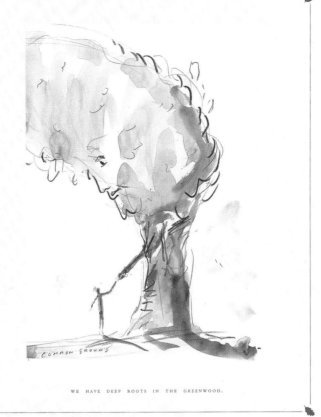

"I FEAR THOSE GREY, OLD MEN OF

There can be no question that trees are physically good for us ~ as sources

of oxygen and negative ions. Yet what will reawaken us to their emotional

MOCCAS PARK," WROTE FRANCIS

value ~ the POWER *and* BEAUTY *of native British trees? The mysterious*

depths of ancient woods are now all too tragically rare in this country.

KILVERT, THE VICTORIAN DIARIST,

Agriculture, disease, acid rain, the cult of the conifer ~ all these have

robbed us since 1945 of half our native tree cover. There hasn't been

"THOSE GREY, GNARLED, LOW~BROWED,

destruction like it since before the Norman Conquest. Trees Woods and

the Green Man is a new campaign designed to alert us by CULTURAL MEANS

KNOCK~KNEED, BOWED, BENT, HUGE,

to the plight of our trees. Trees Woods and The Green Man will encourage

people in the arts to celebrate trees and woods through their work,

STRANGE, LONG~ARMED, DEFORMED,

and so produce an enduring legacy of books, exhibitions, plays and

festivals. BUT WE NEED YOUR HELP. *Trees Woods and The Green Man*

HUNCH~BACKED, MISSHAPEN OAK

urgently requires long term funding. If you can help, write to us for further

details. We will also suggest ways you can fight for and celebrate

MEN THAT STAND WAITING AND

trees and woods in your own neighbourhood. Work to save our

Greenwood. Play your part in TREES WOODS AND THE GREEN MAN.

WATCHING CENTURY AFTER CENTURY."

WE HAVE DEEP ROOTS IN THE GREENWOOD.

A campaign mounted by Common Ground, 45 Shelton Street, London WC2H 9HJ. Charity reg. no. 326375. This project is supported by The Nature Conservancy Council and The Ernest Cook Trust. Designed and illustrated by David Holmes. Written by Jessica Bedstraw. Typography by Peter Wood. Typesetting & Artwork by Keen & Shaw. Printed by Penstock Design and Print. ©Common Ground 1986.

■ **Above** This poster delivers two statements simultaneously: a literary quote in capital letters expounds on the aging character of trees, while a message alerting us to the plight of our forests and woodlands scurries beneath it in small italic type. An effective use of two reading levels (one loud and proud, the other soft and pleading) that delivers a thought-provoking message to our common sense — and echoes the little voice we call our conscience (the whispering of the italic type). Created by agency Holmes Knight Ritchie/WRG for Common Ground Conservation.

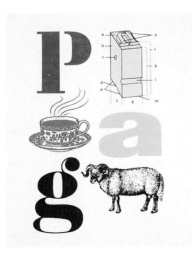

■ **Left** Appearing like some bizarre secret language, images combine to create a word in this rebus of the name "Pentagram." Designed in 1984 by Alan Fletcher of Pentagram.

The use of color

The use of color, in both graphics and typography, is one of the most important and versatile tools we possess, since variations and combinations within the spectrum can be employed to change our perception of visual matter. Similarly a variation in tonal value — that is, the relative density of any given shade — can make a difference, and comes in handy when there are budget restrictions.

Color properties. If we cannot say scientifically that colors have inherent qualities of their own, they have certainly acquired associative characteristics. We tend to see red, for example, as denoting anger or aggression. Pale yellow and green evoke calm and temperateness; blue suggests cold, and white suggests purity.

Symbolic associations. Then there are symbolic associations, many hallowed by centuries of tradition. Because blue can stand for water, it implies hygiene; orange and yellow — the colors of the sun — denote heat; and greens — the colors of vegetation — health and well-being.

Product association. Color therefore plays an important part in product promotion, where these color associations are used to suggest the qualities of the product. Bright blues, greens, and yellows are associated with freshness and cleanliness — and therefore often appear in packaging for household cleaning products as well as personal hygiene and toiletries, whereas delicate pinks and creams are found advertising baby clothes.

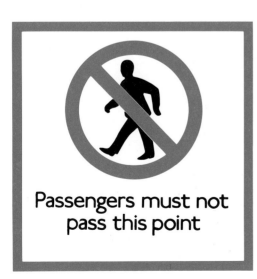

■ **Left** Red implies "danger" and prohibits passage on a warning sign used by the London Underground (posted at the edge of subway station platforms).

■ **Right** Black (combined with white, gold, or silver) is used as a sign of elegance and sophistication in the packaging of cosmetics for both men and women.

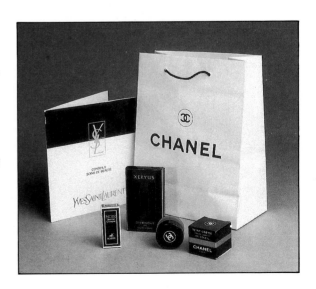

Color distinctions. Color, just like different typefaces and different sizes, can be used to distinguish between different levels or groups of information. It can be particularly useful when the information to be read is complex, as in timetables, forms, annual reports, lists of statistics, detailed price lists, and for some reference books.

Corporate color schemes. Since color has cultural and associative properties, it has a large role to play in the creation of the corporate image by which many clients wish to be identified.

A memorable and readily identifiable color scheme is one of the quickest ways of bringing that corporate image to the attention of the public who can recognize it immediately, even amid the plethora of colors with which they are assailed. Where store signs on a busy main street are competing with each other and shopping bags are a walking advertisement on public transportation, striking corporate colors can become an organization's flag.

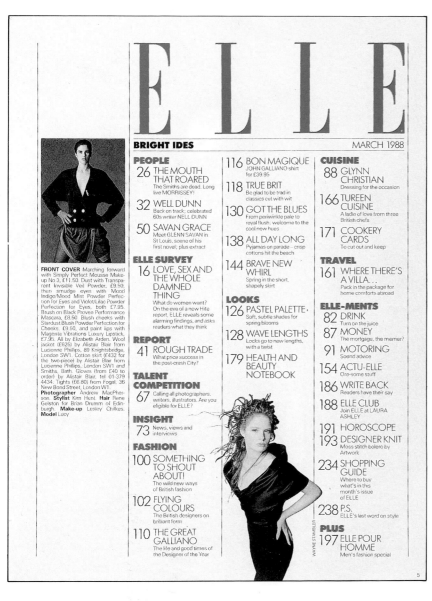

FRONT COVER Marching forward with Simply Perfect Mousse Make-up No 3, £11.50. Dust with Transparent Invisible Veil Powder, £9.50, then smudge eyes with Mood Indigo/Mood Mist Powder Perfection for Eyes and Violet/Lilac Powder Perfection for Eyes, £7.95. Brush on Black Proven Performance Mascara, £8.50. Blush cheeks with Stardust Blush Powder Perfection for Cheeks, £9.50, and paint lips with Magenta Vibrations Luxury Lipstick, £7.95. All by Elizabeth Arden. Wool jacket (£625) by Alistair Blair from Lucienne Phillips, 89 Knightsbridge, London SW1. Cotton skirt (£432 for the two-piece) by Alistair Blair from Lucienne Phillips, London SW1 and Smiths, Bath. Gloves (from £40 to order) by Alistair Blair, tel 01-379 4434. Tights (£6.80) from Fogal, 36 New Bond Street, London W1. **Photographer** Andrew MacPherson. **Stylist** Kim Hunt. **Hair** Rene Gelston for Brian Drumm of Edinburgh. **Make-up** Lesley Chilkes. **Model** Lucy

5

Color and marketing strategy. Color can be used to capture the attention of particular groups of people where it can be helpful in creating a product image of greater appeal to young or old, town or country dwellers, different income groups, or people of different ethnic origin.

■ **Above** A well-organized contents page from *Elle* magazine, showing main headings highlighted in color.

■ **Right** An assortment of different services offered by the British Post Office, which display its long-established corporate color of red.

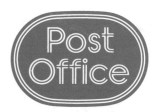

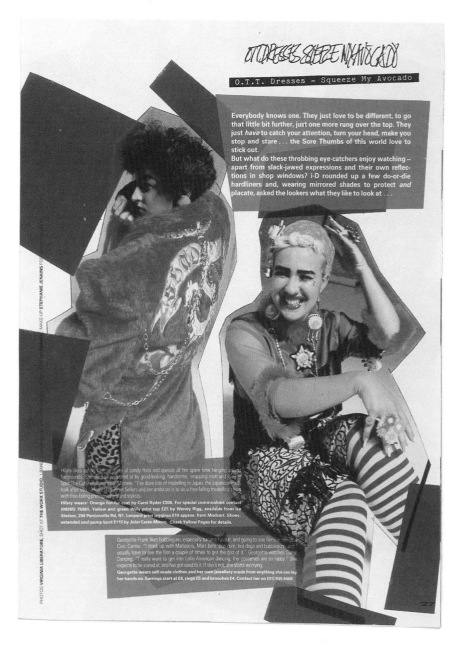

Colored type and legibility. Using color for display type can be effective but you should be aware that legibility can be diminished if the background or surrounding space is also colored, because it may compete with the type.

Other problems can occur if you use colored type and colored backgrounds with text or body copy where greater legibility is needed. You have to experiment with both color and tonal value to ascertain the effects of different hues and shades on readability. You must, as usual, concentrate on the effect you are striving to achieve; and, although this is an area where you can be adventurous, be cautious too, and experiment before committing yourself to print. Build up your own understanding of what happens to color by observing its use in the printed work that confronts you daily.

Group identity. Certain colors have become identified with specific subcultures. The Hippies and Flower People had psychedelic colors; Punks and Day-Glo go together. Football fans declare their loyalties by sporting their team's "colors"; regiments have their standards, nations rally to a flag bearing colored symbols. So knowing what colors, or combination of colors, have come to denote a subculture, you can use them as a form of instantly recognizable shorthand.

■ **Above** A page from *i-D* magazine which relies on distorted type and bizarre colors and poses for its "fringe" fashion image.

■ **Right** Record label for a Bob Marley & the Wailers album, using the colors red, gold and green — symbolic of the Rastafarian religion to which Marley belonged.

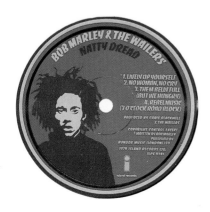

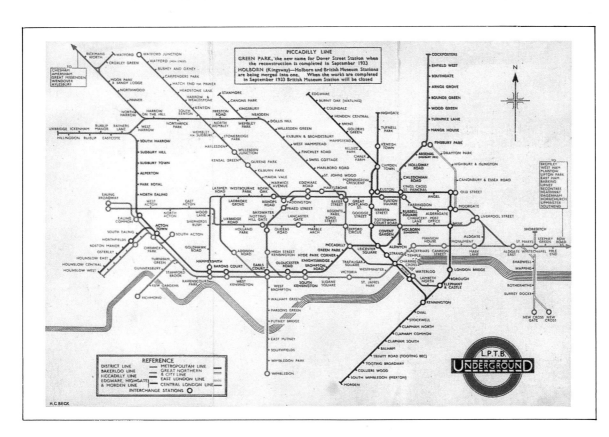

■ **Left** Color coding, used to identify the subway lines on a London Underground map.

Color coding. You can use color to connect similar groups of information, whether words or symbols. "Coding" by color is a particularly useful tool when dealing with public information, where it can become a language of its own and be read by people of varying linguistic origin.

Experimentation. Working with color is fun, but it has its dangers and pitfalls. It is an area in which you have to be particularly cost-conscious and certain that your printer will match your requirements exactly. On the other hand you can, quite economically, achieve amazing results by skillful and judicious juxtapositions. Another subject for observation and experimentation.

■ **Right** Vibrant colors shown on a program cover for a concert of contemporary music. Designed by X3 Posters, London.

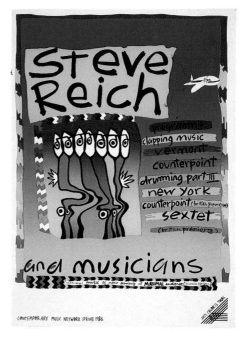

Handwriting, scribbling and scrawling

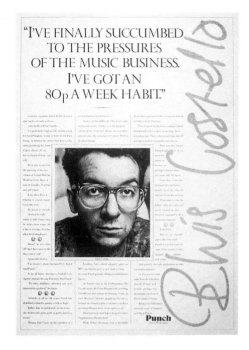

Drawn lettering, calligraphy, handwriting, scribbles and scrawls also have their part to play in creative typography. Where type may have unfortunate or undesirable connotations of a mechanical or authoritarian nature, freehand writing may be preferable. Writing has overtones of intimacy and warmth and can be used to demystify issues or bring information within everyone's reach.

Writing, at one end, is associated with caring about people, events or issues and it can be used where these objectives are paramount. At the other end, frantic letterforms, slash marks or mere scribbles can project powerful emotions; you have only to look at the urgency of graffiti.

Hesitations, whispers, asides or mistakes — hints of human failings — can also be readily conveyed by handwriting in a most subtle way.

■ **Below** Logotype for a bed linen company which uses soft, flowing lines and writing to project comfort, restfulness and other peaceful "home" qualities. Designed for The Chelsea Linen Company by Autograph Design Partnership.

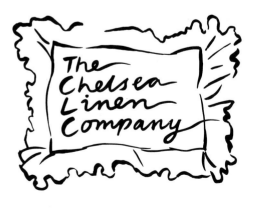

■ **Right** Two press ads (part of a series) created to promote *Punch*, one of Britain's leading satirical magazines. The ads feature amusing and provocative "quotes" by well-known people, adding huge personal signatures for over-the-top authenticity. (Agency: Leagas Delaney Partnership.)

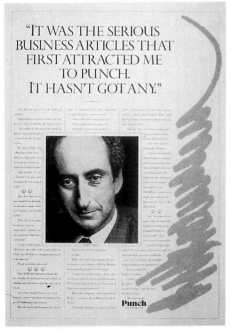

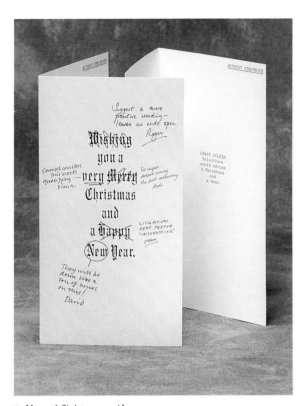

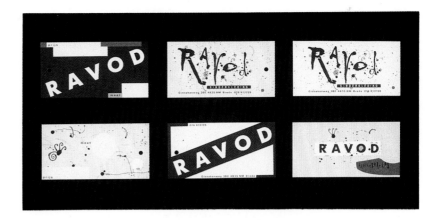

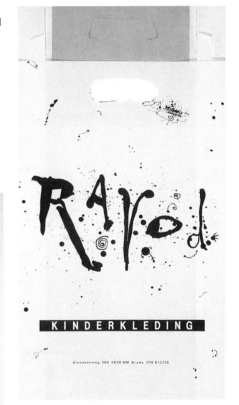

■ **Above and right** Youthful spattering brightens up this visual identity designed for Ravod children's wear by Ton Homburg and Berry van Gerwen of Studio Opera, Holland. (A shopping bag and clothing labels are shown.)

■ **Above** A Christmas card for a firm of British lawyers. Jottings, deletions and scribbled notes poke fun at the world of legal counsel, and the lawyers themselves emerge as a firm with a real sense of humor (check out the inside of the card!). Designed by The Partners for Lewis Silkin Solicitors.

■ **Right** A design which uses loose brush strokes to symbolize nature, health, freedom of spirit...all grasped together like a colorful bouquet of flowers. Promotional material for The Omega Institute for Holistic Studies, designed by Tim Girvin Design of Seattle, Washington.

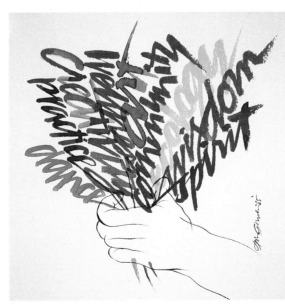

Construction and destruction

There are two other ways in which letters and words can be made to acquire new qualities and, consequently, new meanings. By construction we mean adding something to the letterform or group of letters; this could be by underlining, or enclosing in a box, both devices which give additional importance to the message. We can add decoration to make it more appealing, we can use screens or reversing out to change the emphasis, or we can attach visual jokes to raise a laugh.

Destruction, equally effective in a different way, involves tearing up the letters or words and reassembling them with bits missing, or just blanking them out, or letting them just fade away.

So although type communicates a message through words or language, the tone of voice in which it is delivered is a matter of both typeface and the graphic treatment to which it is subjected. You will want to build up your own catalog of these effects but start by experimenting with each of the suggestions.

DISTORTING IT

MAKING IT DISAPPEAR

SCRATCHING IT OUT

CUTTING BITS OFF IT

ordinary

GIVING IT BORDERS

ordinary

REVERSING IT OUT

ordinary

RULING IT UP

DECORATING IT

ordinary

TEARING IT UP

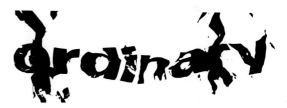

MESSING IT UP

ordinary

MAKING IT 3D

ordinar

SPACING IT OUT

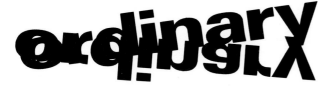

OVERPRINTING IT

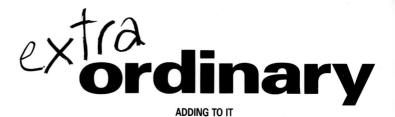

ADDING TO IT

Right A promotional logo for the Contemporary Art Society, designed by Grundy & Northedge. Dots, blocks, signs and arrows express the variety and hubbub of a busy marketplace, while the type has a theatrical flavour — notice the big, fat "ART"...

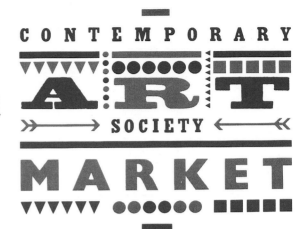

Above left Words and punctuation merge in this logotype by Koeller Associates of Chicago (for Wanger Stores Inc.).

Right A logotype of nothing but dots, representing the punched tape used in telex and print-out machines. Designed for the international news agency, Reuters, by Alan Fletcher of Pentagram, 1973.

Right Logotype for the movie *The Fourth Protocol,* incorporating the name of the film's producer. This design by Howard Brown exploits the language of officialdom and bureaucracy through the use of rubberstamping.

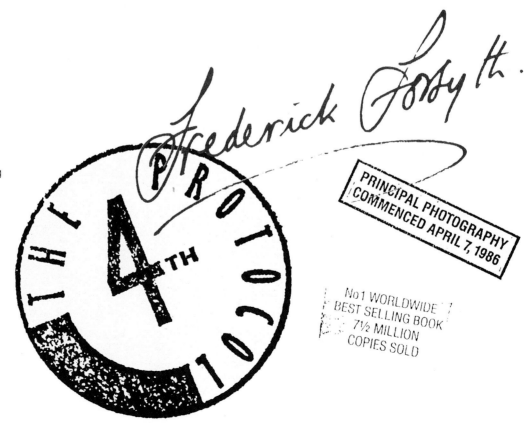

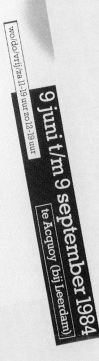

B eelden aan de Linge

Wandelen
van de Kijkschuur naar het fort Asperen
door een prachtig natuurgebied en
Kijken
naar beelden van 50 hedendaagse
kunstenaars uit Nederland

Toegang
uitsluitend via de provinciale weg
Leerdam/Geldermalsen (afslag Acquoy)
alwaar parkeren
Beginpunt
DE KIJKSCHUUR, Lingedijk 84
entree 3 gulden/2 gulden

wo/do/vrij/za 11-19 uur zo 12-19 uur
9 juni t/m 9 september 1984
te Acquoy (bij Leerdam)

■ **Right** Poster for an art
exhibition held in Leerdam,
Holland. Designed by Studio
Dumbar, 1984.

PART 3

METHODOLOGY

PART

3.

METHODOLOGY

Progressing the projects

Now that we have started to build a visual vocabulary of creative elements for you, it is time we put some of them to use.

The projects which follow are:

Type and Lettering Projects	**1, 2**, 3, 4
Type and Color Project	**5**
Type and Image Projects	**6**, 7

Projects **1, 2, 5,** and **6** are, in fact, exercises concerned with the issues that form the basis of using type creatively. They will give us practice in conveying different ideas and meanings through our visual treatment of letters and words, and will help us to explore new ways of combining words and images. Their main objective is to provide an opportunity to exercise the imagination, which plays such a crucial role in devloping a creative approach.

Projects 3, 4, and 7 show how the creative thinking that is used in the exercises can be applied to professional jobs of which some are commercial, some are not. As this involves a more complicated set of procedures, these projects are progressed in stages, from the initial brief through to the end result and the relevant decisions are explained as we proceed. The work stages involved are:

The Brief
Stage One: Brainstorming and Type Roughs
Stage Two: Selecting a Rough
Stage Three: Further Development
The Result

Our model can only provide a general guideline, and should be viewed as flexible. Design is *not* a rigid procedure, and the way that design projects develop can vary. In a real situation, the work stages would not necessarily be as clear-cut as in our model, and indeed, some of those we show might be by-passed. People's patterns of work are unpredictable and changeable, so take our model as a starting point for developing your own personal work method, and refine it to suit yourself.

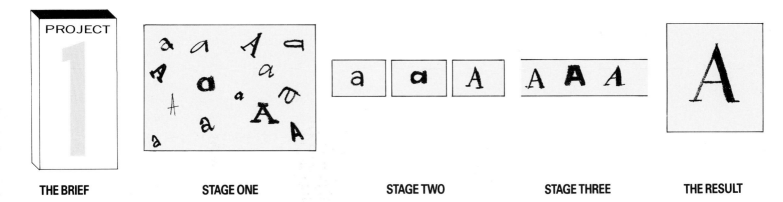

| THE BRIEF | STAGE ONE | STAGE TWO | STAGE THREE | THE RESULT |

The Brief. This is a statement of the task you are asked to carry out or of the design problem to be solved. We will show the brief in a "project box," and where exercises are broadly based, we will suggest possible variant solutions.

In professional life, the brief nearly always specifies the client's requirements and the limitations imposed by time and money. There may be constraints on the amount of color to be used; a restriction to line reproduction; the work may have to be sent to a specific printer — all conditions which influence the way a design is developed. We have not, however, held you down in any of these ways in order to allow our examples to be used in the fullest possible number of ways.

Stage One: Brainstorming and Type Roughs.
The first stage involves a combination of two activities. The first, brainstorming, is a simple method of generating ideas. Take the main topic or issue set out in the brief and, thinking about it in a completely free and unrestrained manner, jot down all the thoughts that come to mind, whether as words or images, and any idea that occurs even if its immediate relevance is not obvious. The important thing is to get everything down on paper. The point of this is to broaden your view of the topic concerned, open your mind to new avenues of approach, allow ideas to surface that are not immediately apparent and to give you a conspectus of the topic from a variety of different angles. In short, it allows you to cast your net as widely as possible for ideas and impressions.

Everyone has their own method of brainstorming. Sometimes it is useful to impose a time limit, so that the flow of ideas is fast and furious; sometimes it is best done with a partner or in a group, for two heads can often be better than one. Since the main objective is to set up a free flow of ideas, it is *not* useful to start rejecting them while brainstorming, or to impose a narrow direction on the proceedings; this defeats the purpose. Although some of the ideas that surface may seem off the track or irrelevant at the time, they may prove to be useful at some later point when you have to start making decisions about the approach to be taken.

The second activity in this stage, often done simultaneously with brainstorming, is that of producing type roughs. This simply involves transferring an idea into a rough visual, using type or a rendition of type. The way you do it, as in brainstorming itself, can be quite personal. Choose the way that suits *you* best. Use pencil, pen, markers or brush, typewriter or word processor, dry transfer type, newspaper cuttings, photocopies of letters and words from type specimen books — any means at your disposal. This is another free-flowing method of working out ideas visually. Do not attempt at this stage to reach a degree of finish that impedes your freedom to try out ideas in different typefaces and sizes. At this stage, access to a photocopier with enlarging and reducing facilities is invaluable.

Whether or not you combine both activities, both are equally important for generating ideas and trying out variations. Unfortunately, even with today's sophisticated technology, we cannot demonstrate in a book the actual brainstorming activity nor what is involved in producing a series of roughs but we do reproduce a sample of the results, for which we have added our reasons for selecting ideas we think can progress to the next stage and why we think others should be rejected. It is important that you develop for yourself the critical faculty that will allow you to assess your own work in an objective way.

IMPORTANT!

Note that projects **1**, **2**, **5**, and **6** will not be taken beyond stage one, as their emphasis is on the generation of ideas rather than on the development of a solution to a particular design problem. However, we have provided comments on these exercises to make apparent why some of the ideas generated are more interesting or effective as visual statements than others. The exercises are followed by examples showing how various designers working on the same type of project have incorporated similar activities or exercises in their work.

Stage Two: Selecting a Rough. In the second stage we have to bring our critical faculties to bear on rejecting and selecting from the roughs we generated in Stage One and then choose one of them for further development. This involves some harsh decision-making where you have to summon up the quality of self-awareness tempered by objectivity that we mentioned earlier. There is not much point in selecting, say, a dozen ideas from Stage One; it just makes the narrowing-down procedure more difficult. Retain two or three ideas only for further consideration at this point, though there may be times when you want to keep as many as six; with more you create an unwieldy situation for yourself.

Once you have selected your potentially usable ideas and roughs, you start to assess their pros and cons, with a view to selecting *one* to be taken on to the next stage. Your criteria here are strength and potential, so you must learn to look beyond the rough in its sketchy form to see what it might become with suitable graphic treatment in the end result. A strong idea will benefit from further development and refinement, and grow stronger; a weak idea, no matter what you do to it graphically, will still be weak at the end of the day.

Developing the ability to recognize a strong idea and see beyond "what it is" to "what it could be" is a matter of practice and experience, but you can make a good start by examining the comments we have included on the projects where we explain our decisions and the reasoning behind them.

Stage Three: Further Development. Once an idea or rough has been chosen for further progression we then become involved in the development of its most appropriate and effective visual form, through our application of graphic treatment. Once again, experience makes it possible to develop a "feel" for the way that graphic treatment can reinforce or enhance an idea. So the process outlined in Stage Three of the projects can most certainly be short-cut with time and practice.

But for our present purposes, Stage Three is about progressing an idea through a series of alterations and changes. We shall direct the journey by posing questions that may arise along the way, and answering them, until we arrive at the final destination.

The Result. Our projects end with what we consider the best possible finished result, but as a matter of interest, we will also show additional applications of the final design.

All of the projects are followed by examples of work, by a variety of designers, which show solutions to similar design problems, or which show how the main issues handled in our projects and exercises can be applied to a broad range of designs.

TYPE & LETTERING

TYPE

& LETTERING

PROJECT

Pick any letter from the alphabet.

Then select a word beginning with that letter.

Now set about conveying the meaning of the word by your choice of type style for the opening letter.

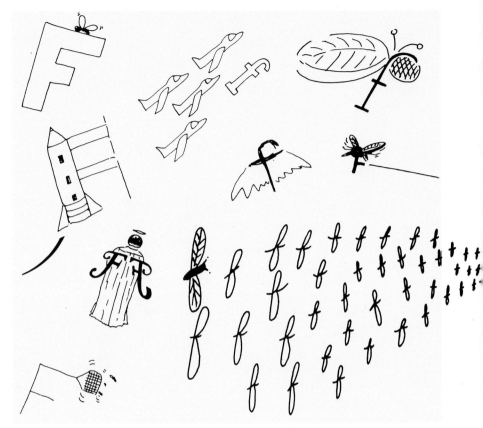

■ **Above** "F for Fly": a group of sketches that are great fun, although some are over-complicated (like the angel with wings). The swarm of flies, or rather the swarm of f's, is particularly endearing — and skillfully matches the shape of a letter to an idea.

Variation: take a word, and show its meaning through your treatment of one (or more) of the letters *within* the word.

Communication through letters

This project, however simple it may seem, is designed to exercise your skill in selecting or drawing the appropriate typeface to convey without ambiguity the *meaning* of your chosen word.

Moreover, it is a good practical method of discovering the power of individual letters to give visual expression to the idea you are trying to communicate and to set your imagination working on the possible design features to be exploited. You will find it an invaluable exercise when you next tackle a commercial brief, so spend some time working your way through the entire alphabet. Keep both your working roughs and your finished drawings in a sketchbook or ideas book, because even if some of them seem irrelevant, they may turn out to be useful drafts for future design jobs.

It is important to look back at your work a few days later, when you have distanced yourself from the immediate creative burst of ideas, and assess your performance, so that you become self-critical and make a more objective judgment about their relative merits.

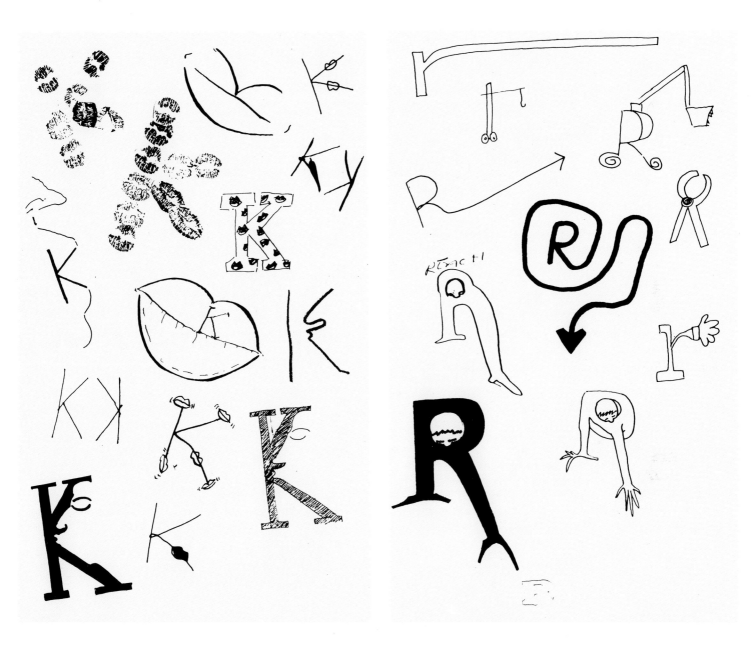

■ **Above** "K for Kiss": this is a difficult word to interpret through a letterform! The letter K is an awkward and complicated shape, and this causes difficulties when trying to express a simple idea in a simple way. Most of the sketches here suffer from being too fussy, or too obscure. But having said that, the sketch at the bottom left corner of the box shows imagination and wit by combining two profiles (the outline of the face, and the outer edge of the letter).

■ **Above** "R for Reach": if viewed simply as rough ideas, there are some interesting possibilities in this group. The simpler sketches, based on stretching or extending the letter, have potential and the illustrated cap R, with a human head and an outstretched arm, is highly imaginative — and could be useful within a humorous situation.

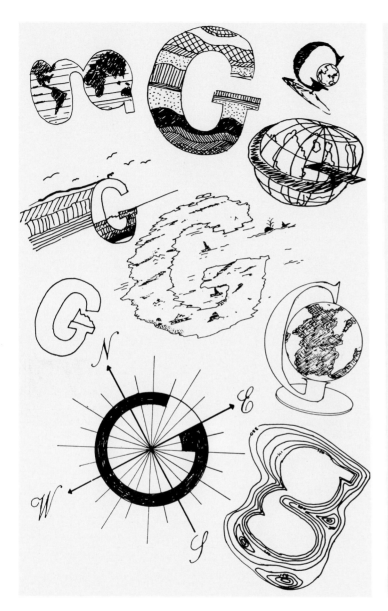

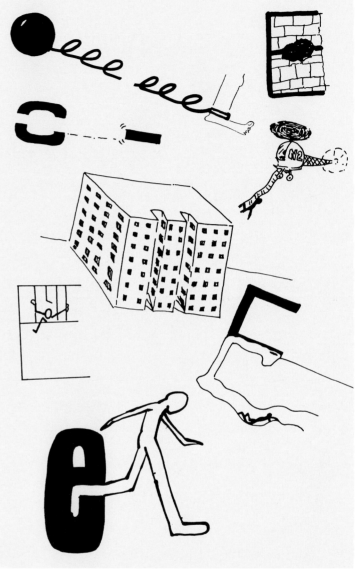

■ **Above** "G for Geography": this group contains some lovely ideas, roughly based on maps, terrains, and the patterns derived from stratified layers of rock. The use of the globe could be particularly interesting with further refinement. Also, there is a nice sense of freedom and experimentation within this group, in that the letterforms are beginning to extend beyond their normal rigid shape.

Above "E for Escape": an extremely amusing collection of ideas, and a good example of how much fun this exercise can be. It's important to recognize that a serious approach is not always useful when searching for ideas; in fact, it can sometimes restrain your imagination. There is no harm in sketching out ideas in a humorous form; the tone can always be made more serious through graphic treatment. Getting the *idea* is what counts.

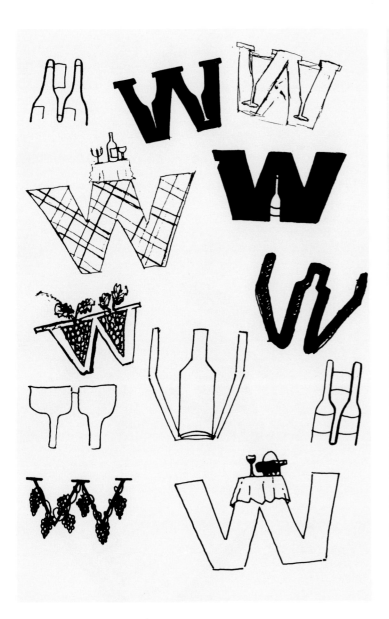

Above "W for Wine": problems arise in attempting to combine the complicated shape of a wine bottle or wine glass, with the equally complicated shape of the letter "W." The most successful sketches in this group involve the use of a large, dominant W and a smaller, related image (such as the table setting, or a wine bottle). Attempts to merge the image into the shape of the letterform tend to appear unclear.

Above "T for Time": is expressed here in fairly mediocre and unexciting forms…This group needs to go back to the drawing board! In this instance, a brainstorming session (and exchanging ideas with other people) would broaden the scope.

The commercial projects that follow demonstrate the creative potential of letterforms — and how they can communicate a wide variety of messages.

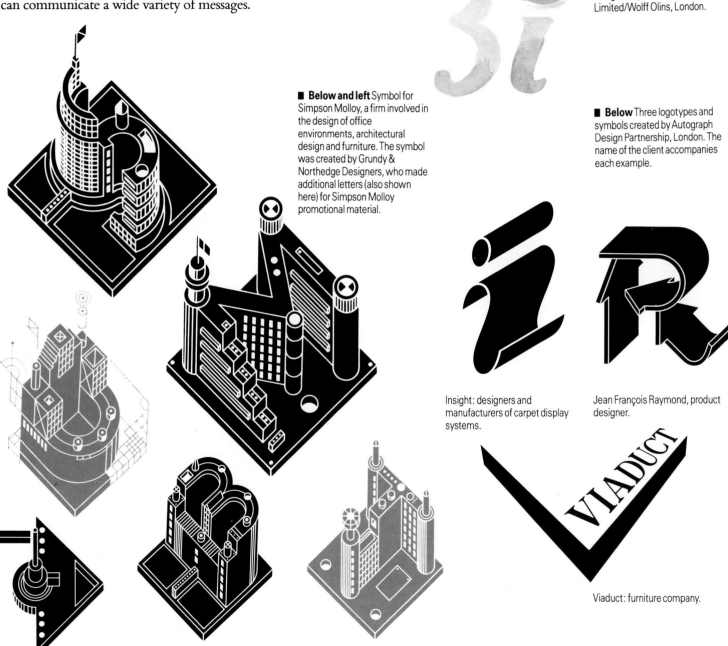

■ **Left** A soft-edged symbol for Investors in Industry (3i), designed by Michael Wolff Limited/Wolff Olins, London.

■ **Below and left** Symbol for Simpson Molloy, a firm involved in the design of office environments, architectural design and furniture. The symbol was created by Grundy & Northedge Designers, who made additional letters (also shown here) for Simpson Molloy promotional material.

■ **Below** Three logotypes and symbols created by Autograph Design Partnership, London. The name of the client accompanies each example.

Insight: designers and manufacturers of carpet display systems.

Jean François Raymond, product designer.

Viaduct: furniture company.

■ **Left** This poster uses a mix of styles, typefaces, images and isolated letters to convey the abundance of ideas, products and pleasure provided by the world of design. Created as promotional material for the Royal Society of Arts Design Bursaries competition (1987) by The Small Back Room, London.

■ **Below** This page presents an assortment of symbols showing how individual letters can be used to create powerful and meaningful statements — often by very simple means (such as modifying one stroke of the letter).

Symbol for Lucentum printing firm, Fernando Medina, Montreal, Canada, 1979.

Symbol for Cinetécnica, Fernando Medina, 1979.

Symbol for Art Pub, Fernando Medina, 1981.

Symbol for "Liber '83" International Book Fair, Fernando Medina, 1982.

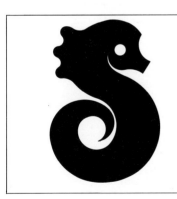

Symbol for a vacation club on the Costa del Sol, Spain, Fernando Medina, 1970.

Symbol for One Realty Corporation, Paul Black of Sibley/ Peteet Design Inc., USA.

Symbol for Manhattan Laundry & Dry Cleaning, Don Arday of Eisenberg Inc., USA.

Symbol for an art exhibition on the theme of "elephant," Christine Barrow, London, 1984.

xaggerate Magnify (thing described, or abs.) beyond the limits of truth; intensify; make abnormal size.

xcite Set in motion, rouse up, alert, (feelings, faculties, etc.); provoke, to bring about, (action, activities etc.) by stimulus.

■ Spreads from the book *A Dictionary of X Words* by Peter Grundy of Grundy & Northedge Designers, 1977. A playful personal project in which various word definitions are expressed through typographic interpretations of the letter "X."

xclamation Exclaiming! note of-(!); cry out! esp. from pain! anger! accuse loudly! (words etc.)

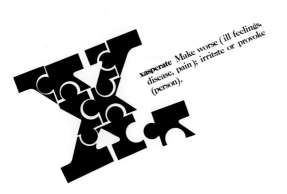

xasperate Make worse (ill feelings, disease, pain); irritate or provoke (person).

xcess Outrage; an intemperance in eating or drinking; over stepping of due limits; fact of exceeding to an extreme degree.

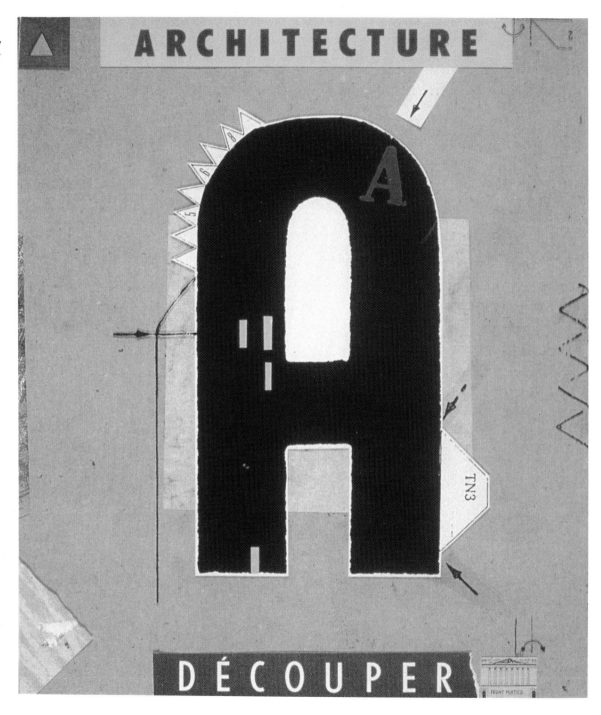

Right A book jacket relating to architectural cutouts, designed by Ton Homburg, Jan Bolle and Berry van Gerwen of Studio Opera, Holland.

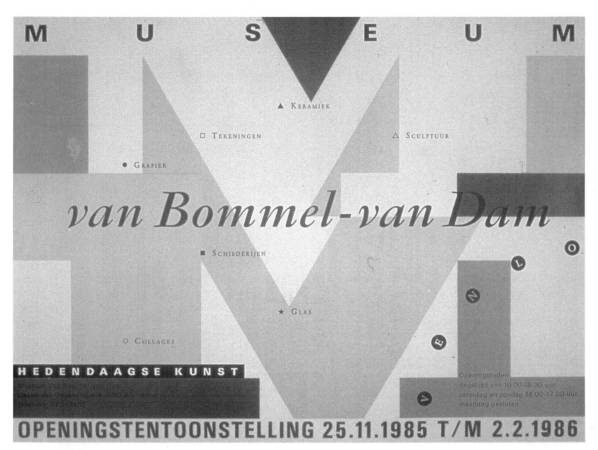

■ **Left** Poster design based on the letter "M" for the Museum Van Bommel-Van Dam. Designed by Hans Arnold and Ton Homburg of Studio Opera, Holland.

■ **Below** Symbol for the Stravinsky Festival Trust, designed by Alan Fletcher of Pentagram, 1979. The symbol is contrived from the visual similarities between a classic treble clef sign and the initial letter of the composer's name.

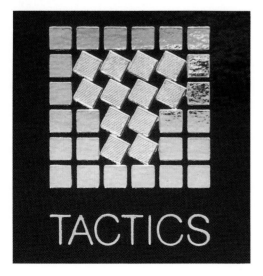

■ **Left** Mervyn Kurlansky of Pentagram created this symbol for "Tactics," a range of high quality men's cosmetics manufactured in Japan by Shiseido (1977). The symbol is based on the checkerboard; by manipulating the squares to create a letter "T" the design not only represents the brand name but also suggests the concept of gamesmanship.

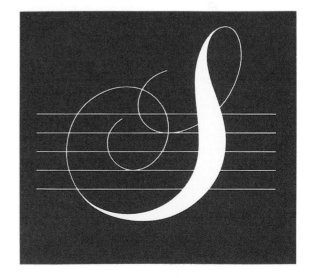

PROJECT

Depict the meaning of a whole word through your typographic treatment of that word.

Make it easier for yourself by setting it within a square format so that you have to work within a defined space which has clear edges (or the space could be rectangular).

Variation: do the same exercise in 3D, using cardboard, paper, or any other material you think would be appropriate.

Working with words

This exercise, an old favorite of many designers, is one which reminds us that words are not just lifeless blobs of copy on the page. By themselves they convey information, and arranged in a certain order, they communicate complex ideas. It is the designer's job to make this communication as rapidly and pleasurably accessible as possible. You cannot practice this exercise too often. Try it with simple words to start with, although you may find them more difficult than complicated ones. The ambitious might like to take an entry from a thesaurus and try *all* the variations given there.

Above "Turbulent": the main difficulty with a word like "turbulent" is that an expressive interpretation of its meaning can easily become unreadable. The roughs shown above are fairly restrained, and therefore lacking in excitement — except for the rough in the bottom right corner of the box. This particular rough depicts a tumbling sort of movement, which is freer and more "alive" than any of the others. Admittedly, there are readability problems, but these could be sorted out quite easily by adjusting a few of the letters. The important thing is that it catches the "spirit" of the word.

Right "Heaven & Hell": this phrase brings all sorts of extraordinary images to mind, relating to either angels or devils. It's interesting to note, however, that the most intriguing sketches in the box tend to deal with simple concepts, such as positioning (ie, the "suggestion" of above and below) or the use of contrasting typefaces — light, decorative type for Heaven and bold, heavy type for Hell. Good, humorous use is made of positioning in the rough on the left, where a cap H stretches from Heaven to Hell! The bottom roughs are also interesting in that they rely solely on manipulating aspects of the

existing letterforms — such as extending the arm of the H, or moving the crossbar of the H to appear above Heaven and below Hell. When the phrase or word to be interpreted is already overloaded with familiar imagery, a simple, suggestive approach is often the best route to take.

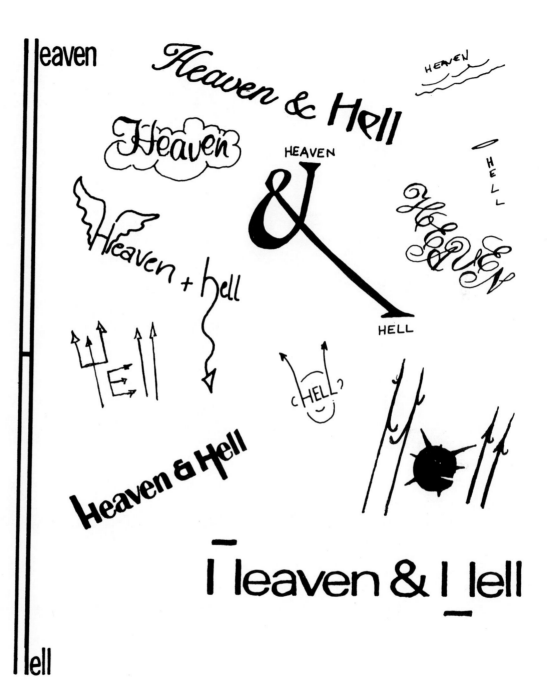

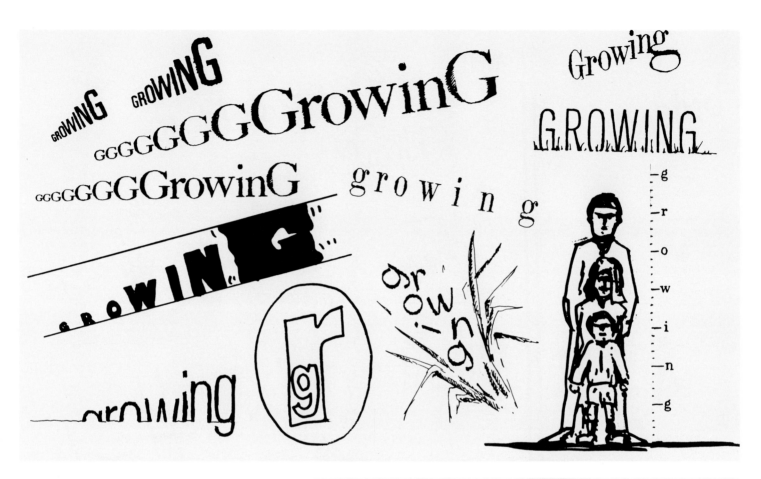

Above "Growing": an easy word to depict — the difficulty is in coming up with an unusual rendition. A number of the roughs above do the job by gradually enlarging the letters; those that revert to illustration are not very successful. The most interesting version rests in the bottom left corner of the box, where hidden letters slowly reveal themselves as if emerging from the soil.

Right "Summer": the sketches shown here are overworked to a considerable extent, although there are some nice ideas — such as an S wearing a hat beneath the summer sun, and letters rising like bubbles in a fizzy drink.

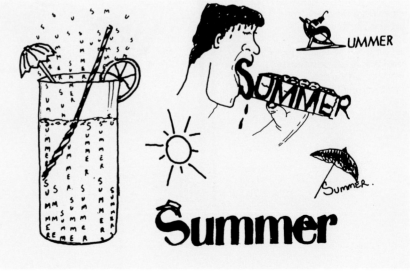

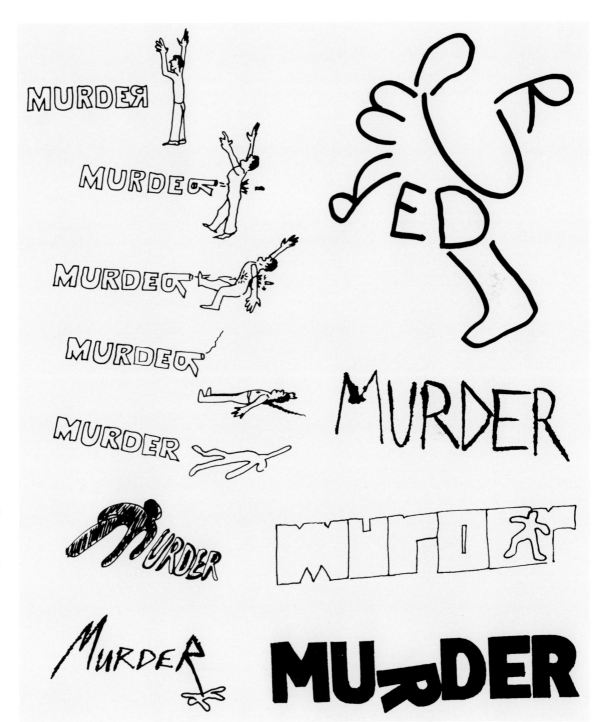

Right "Murder": a colorful word that yields some rather bizarre roughs! Once again, the difficulty lies in over-familiar imagery, ranging from blood dripping from letters, to the chalk outline of a murder victim. Similar to "Heaven & Hell," the key here is simplicity — using the letters to "suggest" murder (like the R lying on its back), rather than attempting to illustrate it.

The following pages show typographic interpretations of words (and their meanings) featured in a broad range of design projects — from exhibition display panels to stationery.

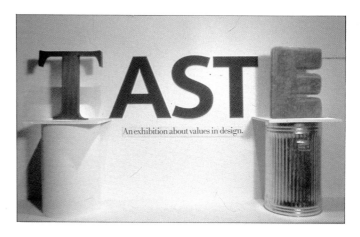

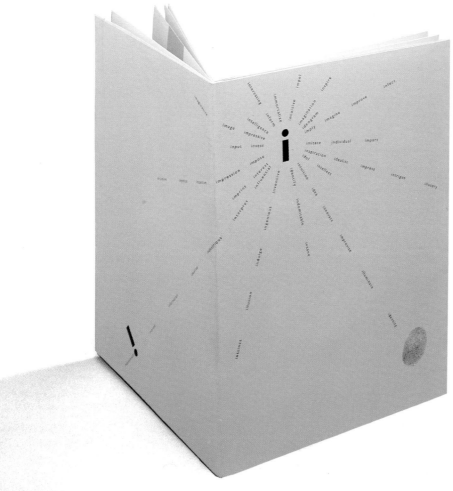

■ **Above** Design for an exhibition on Taste (held at the Boilerhouse, London) by Minale Tattersfield & Partners. The main introductory panel is shown here, with the title displaying a Roman "T" standing on a white pedestal and a furry pink "E" on a garbage can. This feature was used in the exhibition to clarify which items (ranging in size from large pieces of furniture to delicate ceramics) were considered to be in good or bad taste. All those objects in good taste were displayed on pure white cylindrical pedestals, while those in bad taste were displayed on garbage cans!

■ **Left** Cover design for Howard Brown's "identity" brochure (a self-promotion piece), based on the letter "i" and words that begin with it.

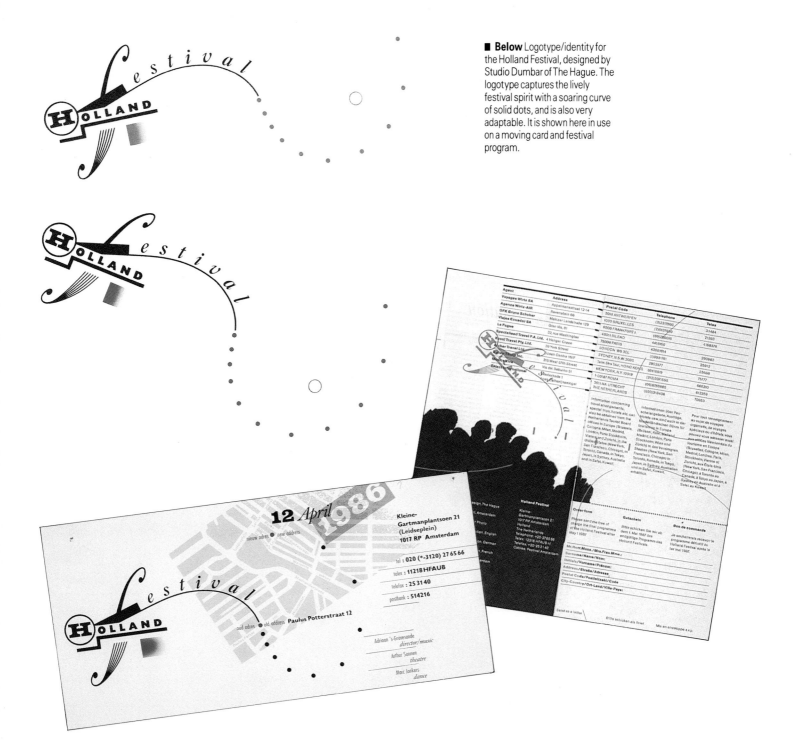

■ **Below** Logotype/identity for the Holland Festival, designed by Studio Dumbar of The Hague. The logotype captures the lively festival spirit with a soaring curve of solid dots, and is also very adaptable. It is shown here in use on a moving card and festival program.

ECLIPSE

Above Logotype for "Eclipse," a solar reflective architectural glass product. Designed by Jeff Kimble of Toledo, Ohio, for Libbey-Owens-Ford Company. The meaning of the word is conveyed by the definition of a white shape, which partially eclipses the letter "L" and turns the "C" into a crescent-shape.

bow tie

Above A complex and elegant illustration by Grundy & Northedge Designers, which also manages to be slightly humorous.

Right A wedding invitation that visually celebrates "two becoming one." Designed by Huber & Huber, USA.

TWONE

CELEBRATE WITH US AS TWO BECOME ONE
Audrey and Ozzy Maters invite you to the
marriage of their daughter Helen
to Paul Huber Jr on Sunday, August 25, 1985.
The ceremony will begin at one o'clock in the afternoon,
with a cocktail reception immediately following.
85 Sunnyside Lane, Westbury, New York
Return card enclosed

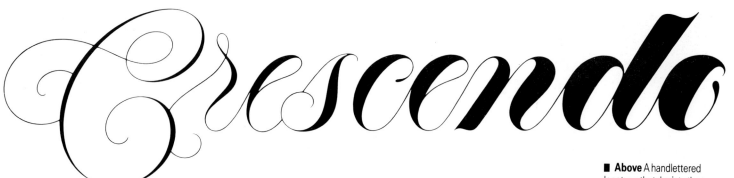

■ **Above** A handlettered logotype that depicts the meaning of the term "crescendo" by gradually thickening the stroke of the letters. Designed by Ken Shafer of Dallas, Texas. (Studio: Richard Brock Miller Mitchell and Associates.)

DEADLINES NEED EXTENDING Mistooks are made

WORKLOADS BUILD UP

THINGS DON'T GO SMOOTHLY

BOTTLE NECKS DEVELOP

Pressures increase

ABSENCES NEED TO BE COVERED

EFFICIENCY DROPS

Targets are miss d

PLANS NEED CHANGING

The longer illness lasts, the worse disruption gets

Look what happens when your employees fall ill.

But it doesn't have to be this way. Not if your company is with BUPA. Ours is a total approach to company health that ensures when illness strikes, the problems it causes are kept to a minimum. We call it Health Care Management and it goes far beyond health insurance for your key employees.

For a start we check the health, both physical and psychological, of your workforce. We can often detect illnesses before outward symptoms become apparent, enabling early corrective action to be taken. Then we examine their working environment for potential problems and advise you of health hazards. Needless to say if a stay in hospital is needed, your employees could get the best available treatment at a time that suits everyone, perhaps in one of our very own BUPA hospitals. If all of this sounds eminently sensible, then you'll understand why 70 companies a week join BUPA. Shouldn't you be one of them?

BUPA, Provident House, Essex Street, London WC2R 3AX, Telephone 01-353 5212.

BUPA

Britain feels better for it.

■ **Left** Advertisement for medical insurance, promoting a company health policy. Typographic interpretations are used to enhance the meaning and impact of statements that describe the problems that illness can bring to a company. Created by Chetwynd Haddons agency for Britain's BUPA.

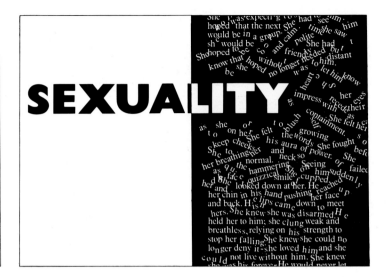

The text column (romantic novel parody) reads:

> ...She wasn't expecting to see him. She had hoped that the next time she saw him would be in a group. She had hoped that she would be cool and calm. She had hoped to be polite and friendly but distant. She had hoped, without words, to let him know that she no longer needed him. She had hoped to impress with her self containment. She felt her calm recede as their eyes met. She felt the blush growing on her cheeks and her neck. She fought to keep her breathing normal. She failed to quieten the hammering of her heart. Seeing him suddenly she was surprised, as she had been before at his aura of power. She tried to speak. The words seemed to stick at the back of her throat. He walked slowly towards her with that so familiar quizzical smile on his face. He reached her and looked down at her. He cupped her chin in his hand pushing her face up and back. His lips came down to meet hers. She knew she was disarmed. He held her to him; she clung weak and breathless, relying on his strength to stop her falling. She knew she could no longer deny it - she loved him and she could not live without him. She knew she was his forever. He would never let...

A STUDY GUIDE

SEXUALITY

PICTURES OF WOMEN

Written and compiled by Leslie Morphy

Designed by Liz McQuiston

Picture research by Celia Dearing

This study guide is based on six television programmes made by Pictures of Women Productions for Channel 4

SEXUALITY

■ **Above** Inside front cover and inside back cover of a booklet produced as broadcast support material for Channel Four Television; designed by Liz McQuiston, London, 1984. The booklet accompanied a series of feminist programs dealing with sexuality. The column of type on the inside front cover is a parody of a romantic novel; on the inside back cover, the series title (*Sexuality*) is used symbolically to shatter the conventions represented by the romantic novel.

■ **Right** A Christmas card which cleverly contracts "Samata" to "Santa"; designed by Pat and Greg Samata of Samata Associates, Dundee, Illinois.

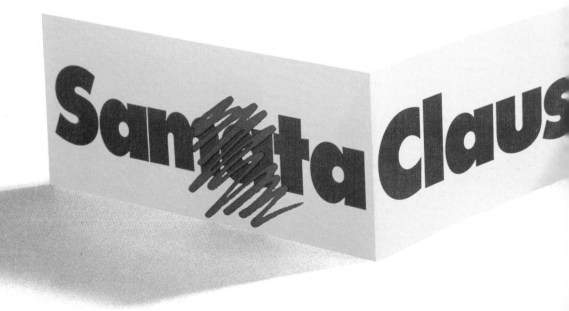

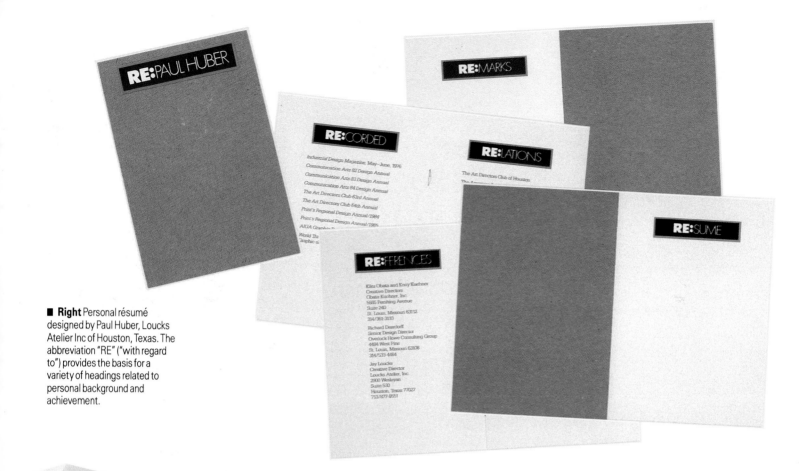

■ Right Personal résumé designed by Paul Huber, Loucks Atelier Inc of Houston, Texas. The abbreviation "RE" ("with regard to") provides the basis for a variety of headings related to personal background and achievement.

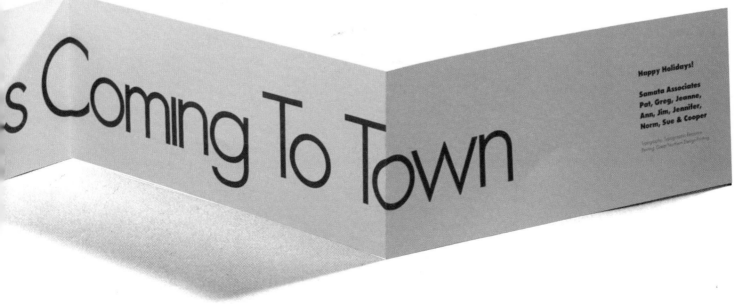

PROJECT

Take the name of a person or an organization and convey through your treatment of it the personal or corporate image it conjures up.

We have chosen "Hendrix," with the intention of producing a logotype for a film on the late Jimi Hendrix.

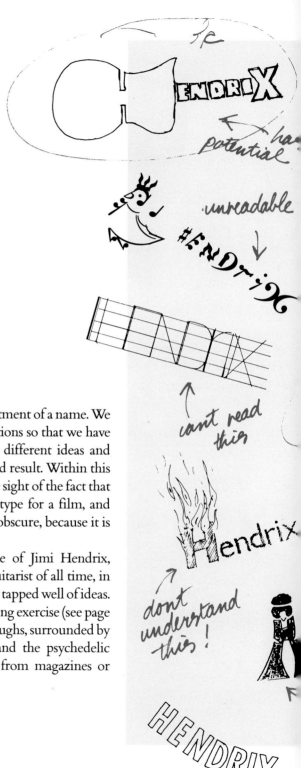

Stage One

Designers are frequently asked to produce an instantly recognizable logotype for a client. Most designs start from the letters that make up the name or the initials of the organization or person. The end result is intended to project a particular image which communicates the nature of the business, or the interests of the person concerned. The graphic solution will then be used on letterheads, brochures, posters, or any other printed matter and become part of their public image.

It is therefore imperative that the designer should discuss at an early stage what qualities or ideas the client wishes to be recognized by. As an example of how to set about this kind of design job, our project deals with the basic issue of conveying personality through visual treatment of a name. We start without preconceived notions so that we have complete freedom to explore different ideas and solutions on our way to the end result. Within this flexible approach we never lose sight of the fact that our brief is to produce a logotype for a film, and that it must on no account be obscure, because it is aimed at a wide audience.

We have chosen the name of Jimi Hendrix, perhaps the greatest electric guitarist of all time, in order to give ourselves an easily tapped well of ideas. The first step is the brainstorming exercise (see page 49) from which emerge type roughs, surrounded by themes such as rock music and the psychedelic symbols of the 1960s, culled from magazines or record sleeves.

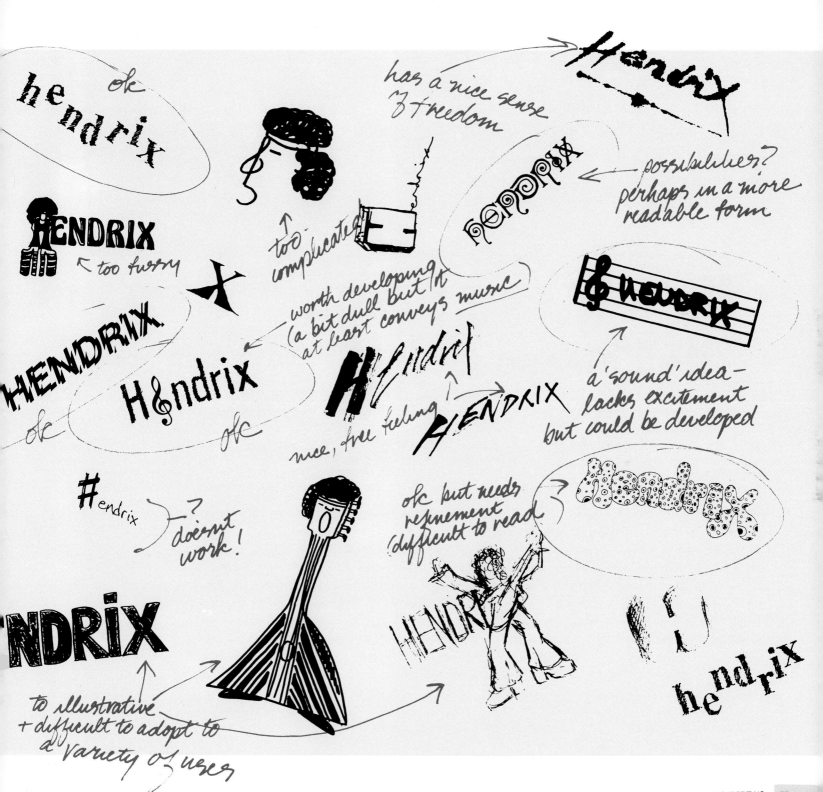

The roughs shown on this (and the adjacent) page were selected from the brainstorming session. All of the roughs are fairly interesting but no particular idea stands out above the others. Nonetheless, it is important to review each one, in order to ascertain which has the most potential for further development.

Below left Substituting a treble clef sign for one of the letters in the name "Hendrix" is a nice idea, but in this instance it disrupts the reading of the word too much. Another problem: there is nothing to suggest a wild spirit or unorthodox musical talent.

Below A nice attempt to put some "electricity" into the name (with reference to the electric guitar). But the connection with music is no longer obvious and would not be understood by a wide audience.

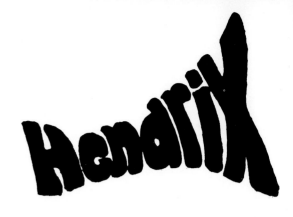

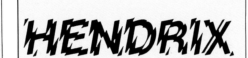

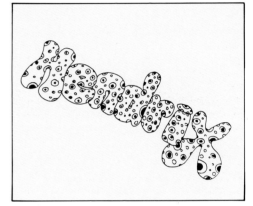

Stage Two

From the large number of roughs accumulated from the brainstorming session, we make a selection of the ones we think have potential. All the ideas contained in them are relevant but none seems exactly right. No particular idea stands out above the others, a common enough situation. How then do we know which to pursue?

The ability to assess the difference between an idea which stands a chance of becoming *the* solution and those that don't comes from experience, but a number of factors are involved. It is helpful to have a check list which will become second nature with practice:

will it appeal to the intended audience?
can it be executed within the budget limitations?
will it communicate its message clearly?
is the idea strong enough to withstand changes that may be made later?

The rough we have chosen (shown on the extreme right) fulfills these criteria we have set ourselves. It has the potential to appeal to a wide audience and it communicates an association with the right kind of music. However, it still lacks the personal aspect, the feeling of wildness and rebellion that were Jimi Hendrix's hallmarks, and this is what we have to concentrate on next.

Below Three variations on an essentially interesting idea — but each suffers from the fact that it is just too complicated in its execution. Consequently, it would be difficult to adopt any of these for a broad range of uses.

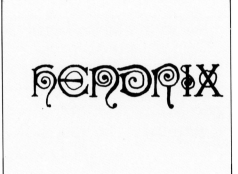

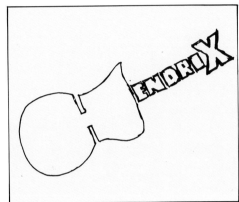

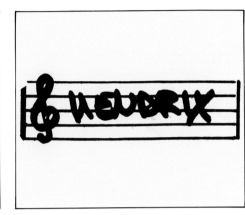

Above and left The three examples shown are similar, in that they all use a psychedelic or decorated typeface of one sort or another. An interesting approach in visual terms, but they don't say anything about music or about Hendrix as a person. (The examples shown here are also difficult to read.) What lies at the heart of the problem is that there is little substance to the idea. Apart from "looking pretty," they don't have much to say and, because of their fussiness, would be difficult to apply to a variety of uses.

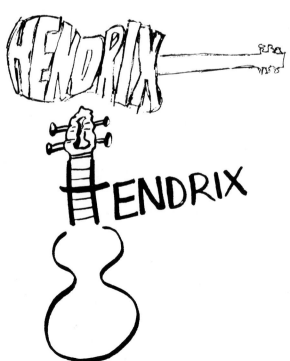

Above This version is carried over to Stage Three. It possesses two necessary ingredients: the suggestion of music, and the name. Both are in a somewhat bland form at present, but they provide a base on which to build — and are likely to benefit from further development. The main point is to inject excitement into these elements in Stage Three.

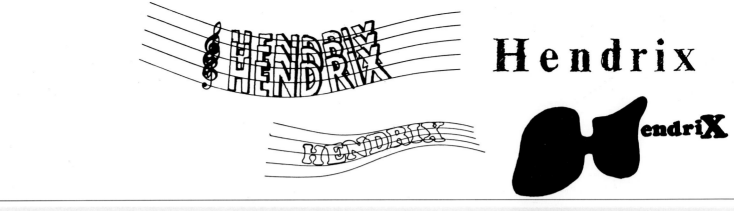

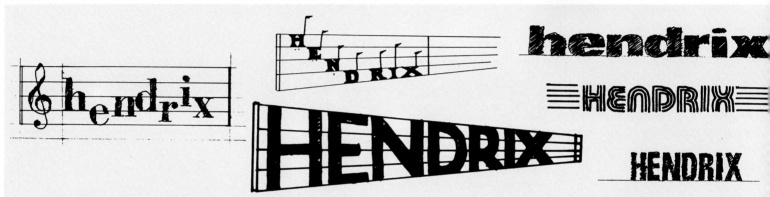

Stage Three

Since we know that the logotype has to be used in a variety of different ways, we have had to restrict ourselves to black and white only. This practical limitation, by denying us the subversive element we might have achieved by color, means that we must reconsider the existing design elements. The series of sketches shown above prompt the following questions concerning both the musical stave and the name Hendrix.

What happens if we distort the stave?

This is certainly an obvious option and, as can be seen, begins to loosen up the rough. We have allowed our drawing to go a bit over the top so that it overwhelms and takes possession of the name. From this we can extrapolate a general application...

Should both the main elements be wild and exciting?

Not necessarily, since if they compete with each other, both elements may lose their impact. So we decided it would be preferable to have one stable element to allow the other to make its point more forcefully. We have therefore reverted to our original version of the stave and turn next to possible variations of treatment for "Hendrix."

Above Attempts to introduce a sense of excitement by altering the musical stave (through use of distortion and perspective) prove to be overwhelming. The personality of Hendrix is lost. The musical stave is best treated as a stable element, and is therefore returned to its normal appearance. Attention is then directed to the name "Hendrix."

HENDRIX

Hendrix

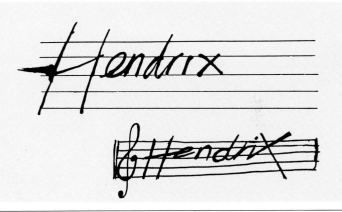

HENDRIX

Hendrix

If we want a wild, free quality to be attached to the name "Hendrix," can we find a suitable typeface to project this?

The various attempts at rendering "Hendrix" in different typefaces shown above have failed to achieve the desired effect. If anything, they make the work look tight and artificial. Since, therefore, no typeface conveys the feeling of freedom and excitement that we are after, we decided to try drawn lettering. The dynamic quality of a loose signature scrawl which acts as a counterbalance to the stiff and static nature of the musical stave is beginning to look right.

Can any other refinements be made?

A dynamic tension has been set up between the freedom of the signature and the rigidity of the stave lines. However the treble clef (G clef) sign is now simply getting in the way. It is best eliminated, and the lines that remain can now *suggest* a musical stave — allowing the audience or reader to use their imagination. The only remaining task is to adjust the size of the signature scrawl in relation to the stave lines.

If the signature is too big, it will overwhelm the lines and make them appear insignificant, which is not at all the desired effect because they are an essential aspect of the design and making a statement in their own right.

Above Various renderings of "Hendrix" in different typefaces fail to achieve the feeling of wildness that is desired. Handwriting, however, proves to have the right feeling of excitement and spontaneity. But once "Hendrix" is written over the stave lines, the treble clef begins to present problems. It is now only a disruptive element, and is best eliminated.

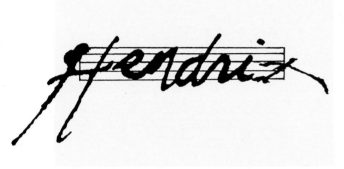

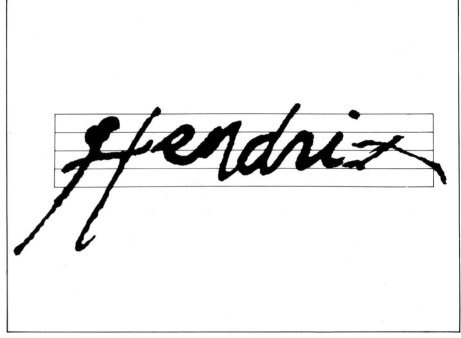

Above Logotype for the film *Jimi Hendrix*, designed by Fernando Medina of Montreal, Canada (1972).

The Result

Here we show the actual logotype produced by designer Fernando Medina, practising in Montreal, Canada, for the film *Jimi Hendrix* (1972). It is bold, direct, and accessible to a broad audience. For those who might be unfamiliar with Hendrix and his music, the logotype makes it clear that he was not a conservative musician — but does not attempt to overstate. A general rule that we can learn from this example is that a good logotype should convey an idea simply and directly; it should not be expected to tell a complex story. It is important to remember that you must not say too much in a logotype by overloading it with meaning.

Here are examples of commercial design work that project a client's profession, personality, or interests. Many of them achieve this through visual treatment of the client's name — but there are a few exceptions, as well as a few surprises!

■ **Below** Symbol for a business computer software company named Risk Decisions, which combines the company's initials with a percentage sign. Designed by Autograph Design Partnership, London.

■ **Right** John McConnell of Pentagram designed this poster in 1985 for The Napoli '99 Foundation. (The Foundation was established in 1984 to heighten awareness of the city's problems and to promote projects for the conservation of the city's cultural heritage.) The design shows a classic typeface falling to pieces, in the same way that buildings collapse, to draw attention to the decaying environment.

■ **Right** A distinctive alphabet produced for the identity of an Italian chemical company by Minale Tattersfield & Partners. The letters and numerals mimic the periodic table of elements used in chemistry.

A^A B^B C^C D^D E^E F^F G^G H^H
I^I $J^{J\cdot}$ K^K L^L M^M N^N O^O P^P
Q^Q R^R S^S T^T U^U V^V W^W X^X
Y^Y Z^Z 1^1 2^2 3^3 4^4 5^5 6^6
7^7 8^8 9^9 0^0

HOT DOG & HAMBURGER

■ **Above right** Logotype for a hamburger restaurant, designed by Fernando Medina of Montreal, Canada. The lettering incorporates the round shape of a plate or, if we apply a bit more imagination, the rounded shapes of hot dogs and hamburgers.

NAPOLI

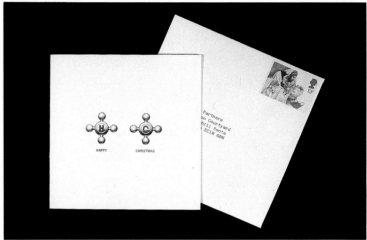

■ **Left and above** Logotype and stationery for a central heating and plumbing firm, which provides amusement in the positioning of the type and images. The logotype is also shown transformed into a Christmas card. Designed by The Partners, London.

PRODUCTION:

SPITTING IMAGE

PRODUCER: LUCK & FLAW
CAMERA: IONA McGLASHAN
SOUND: DAVID AYRES

Left and below Minale Tattersfield & Partners designed this sign system for Central Independent Television studios. A main requirement was that it should be easy to change or update. Color-coded clapper-board-style blanks were printed and then the details chalked onto them before being mounted behind clear plastic sheets. When a studio changes its function or a room changes staff, a new blank is simply filled in and remounted. Their appearance has a spontaneity that enlivens the complex maze of corridors, rooms and studios.

2ND FLOOR

STUDIOS 1/2/3
DRESSING ROOMS
WARDROBE, MAKE UP
GREEN ROOM
MEDICAL CENTRE
DUPLICATING, CASHIER
EDUCATION, WAGES OFFICE
RESTAURANT AND BAR
CENTRAL HOUSE
AUDIENCE RELATIONS
SALES AND MARKETING
PROMOTIONS
PRODUCTION MEETING ROOM

CENTRAL INDEPENDENT TELEVISION PLC

4TH FLOOR

VTR/VAR/CAR/MCR
TELECINE, VTR LIBRARY
CENTRAL AREA SUPERVISORS
PRESENTATION FILM EDITING
POST PRODUTION SUITE, ACR
LIGHTING WORKSHOP
MECHANICAL WORKSHOP
FILM DEPARTMENT
COST ACCOUNTS
GRAPHIC DESIGN

CENTRAL INDEPENDENT TELEVISION PLC

WORDMA®K

■ **Below** Promotional material for Wordmark, the specialist naming division of Landor Associates (see left). Designed by Landor Associates (San Francisco).

■ **Above** Trademark for the specialist naming division of Landor Associates (San Francisco) design firm. This simple but strong design makes use of the abbreviated "R" for Registered (as in a trademark or name).

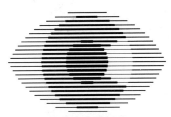

CONTEK

■ **Above and right** Contek
logotype and stationery range by
The Partners, London. The eye
symbol is particularly attractive
when viewed from a distance,
since the image lines produce a
gray tone.

■ **Left** A card offering Christmas
and New Year's Greetings
disguised in the familiar shape of
an eye-testing chart, and
revealing the profession of the
sender. An optician's Christmas
card designed by Howard Brown,
London.

■ **Right** Creative typography…with no type! (But the message is obvious.) Letterheaded stationery for a client specializing in knit design by Darrell Ireland, London.

Karen E Colley, **Knit Design.** *The Mews Flat, Blaze Road, Bromley-by-Bow, London E3 3HN. Telephone 01-981 0115*

Adrian Flowers
Tower House, 46 Tite Street, London SW3 4JA. Telephone 01-352 4511/3

■ **Left** Letterhead and
continuation sheet for
photographer Adrian Flowers;
designed by Darrell Ireland,
London. An elegant photograph of
a vase adorns this subtle
letterhead — and watch out for
the shadow that creeps onto the
continuation sheet!

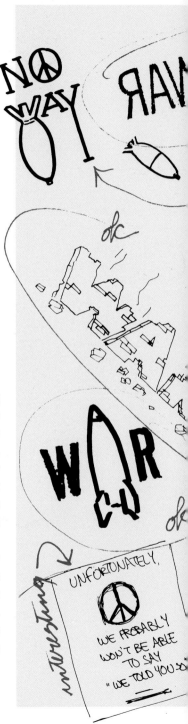

PROJECT

Design a poster on the topic of nuclear arms.

Like Project 3, this brief shows visual communication with type taken from an example in a real-life situation.

Stage One

The subject of this brief was set as an exercise for a selected group of designers, so that the results could be published in an international design journal and show the wide variety of possible solutions, each of which reflected the views and personalities of the designers concerned.

Ruhi Hamid, one of the designers, decided to approach the problem typographically — and in progressing the project through the stages to her end result, we shall see how the previous exercises in conveying meaning through words and letters are put to use in a broad brief.

A topic like nuclear arms involves a number of complicated issues, many of them producing emotive reactions, but a poster is most effective when it puts over a simple statement which does not try to pack in too much. Once again, brainstorming is the best way to start. You are likely to confuse yourself by diving into books or newspapers to assemble facts and figures for the current state of arms manufacture throughout the world. You will certainly confuse your audience.

The brainstorming session on this topic is likely to produce such well-worn and oversize concepts that they may seem either overwhelming or hackneyed, so the first step taken is how to find a quick but new way of conveying basic emotions about the bomb, life and death, and its implications for the whole world.

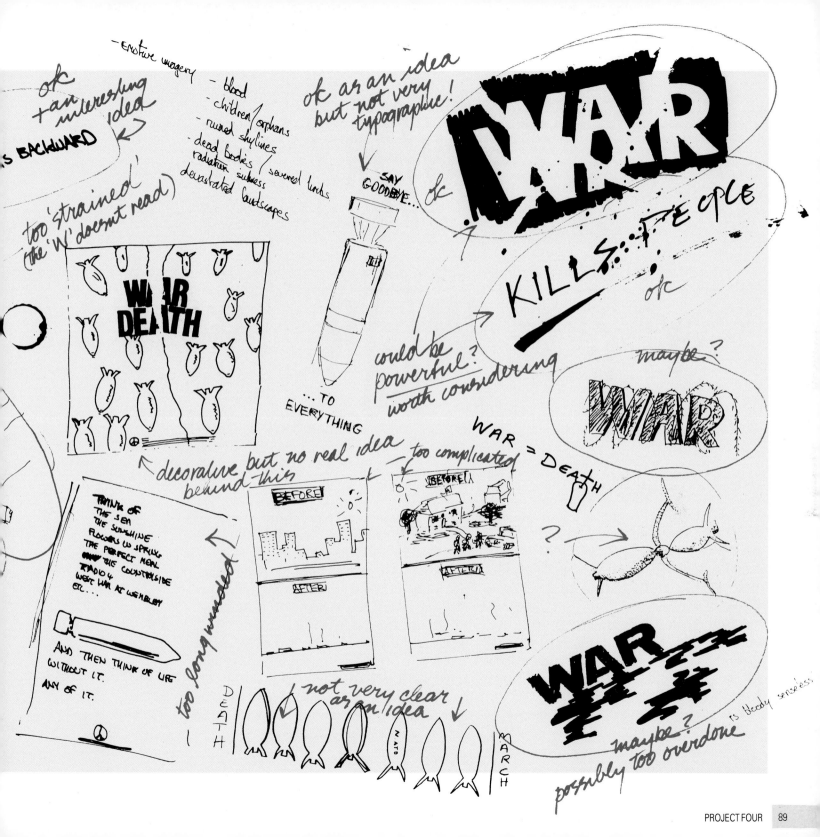

The majority of the ideas retained from the brainstorming session rely heavily on illustration — such as the four versions shown here. The "WAR" made of smoldering bricks and the "WAR" wrapped in barbed wire are both familiar representations. We've seen them many times before, in one form or another. The most interesting sketch is the center one, showing the "A" of "WAR" replaced with a missile. But it is only interesting as a visual device; the comment or statement being made is unclear (is it protesting or promoting?). A nice visual gimmick, but that's not enough…

Stage Two

The first result of brainstorming tells us that some words are more emotive then others. "Nuclear arms" is seen to be a fairly clumsy phrase when compared with the impact made by the single word "war" with its all-encompassing association with feelings of revulsion.

"War" therefore suggests the direction most worth pursuing to yield a powerful yet simple statement, so these roughs have been selected. But we have to go further in our search for a fresh approach or a new interpretation.

The pictorial examples shown in the roughs don't really seem to add anything to the word "war" apart from illustrating it, and actually detract from its impact. On the other hand, the statement "war is backward" makes its point both simply and effectively. It puts across a home truth which is broader than any of the other statements shown. Instead of being overwhelmed by trite images of war such as blood, barbed wire, bombs and destruction, we simply get "war is backward," which produces the instant reaction that war is wrong, and that we all agree it is so. When that statement is reinforced by revising the *order* of the letters, we have a potentially powerful combination: an unambiguous, unassailable message put across by distinctive visual treatment in an unfamiliar but instantly communicative way.

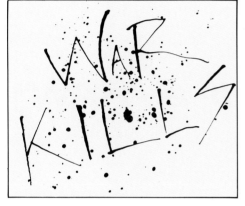

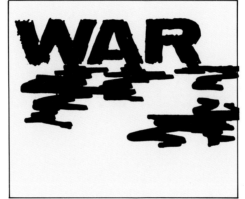

Above and above right Two further illustrative versions are shown here. Both are familiar, if not "tired," renditions of the word "war." The version directly above is of slight interest for what could be unique lettering — but the lettering is not really enhancing the statement being made. If anything, the lettering disrupts the image of spattering blood.

Right The column of roughs on the right show possible variations on the statement "War is backward." As an initial concept, it has a lot to offer — a resonant and meaningful verbal message, and the possibility of dinstinctive visual treatment (reversing letters, and altering the size, weight and positioning of the words, etc). This could be a powerful composition in terms of a straightforward and direct poster image, and so this direction is pursued in the next stage of development.

Right and below When a verbal statement of few words is the central feature of a design, it is very important to get the visual treatment of those words exactly right. Many variations are shown here which attempt to clarify which letters should be reversed, what form they should take, ie. caps or upper and lower case, and what typeface should be used. A uniform sans serif typeface is decided to be appropriate because of its clean, commanding appearance, having a similar effect to headlines that claim attention in newspapers.

ЯAW IS BACKWARD

ɹɐw is backward

WAR ƨi backward

ЯAW is BACKWARD drawkcab ƨi ЯAW

Stage Three

In this case, further development should determine the "tone of voice" in which the message is to be delivered. It could be commanding and authoritative, quietly informative, or pulsing with fear and anger. The designer will express a personal reaction to the whole subject of nuclear arms by which of these approaches, and therefore which typeface, is selected. Reversing the order of the letters is one way of making the statement visually distinctive, if it is to be shouted and create an indelible impression, but thought has to be given to whether the whole statement, one word, or only some letters, and if so which, should be treated in this way.

WAR is ꓭЯAWꓘϽAꓭ

WAR ƨi ꓭAϽKWЯꓷ

ɹɐw IS W BACKWARD

ЯAW IS BACKWARD

Above The reversing of the order of the letters is given careful consideration, and the best effect is produced by reversing only one word ("WAR") and in the form of capitals. Attempts to use lower case, or to reverse the entire statement, cause reading difficulties.

WAR

IS

B A C K W A R D

Below Attention is also given to the arrangement of the words. "WAR" grows in size, is colored red, and is placed above the other words, thereby increasing the resonance of the message.

WAR
is backward

WAR

IS

B A C K W A R D

Above "WAR" is made bolder, and the word "backward" is letterspaced, to prevent the second part of the statement from being overpowered. As an experiment, the word "WAR" is given a black background in an attempt to increase the dramatic impact. It doesn't work — boxing it up in this manner only divides the entire statement in an undesirable way.

If reversing the order of letters, then to what extent? and in what arrangement?

The sequence of roughs (left and above) shows that this question is not easily resolved. But as the intention is to use this device as a major feature of the design, it is important to persevere and get it right. By trying out alternatives it becomes apparent that reversing the entire statement is a mistake because it slows down reaction time, so it is better to reverse only the word "WAR." Note that caps fare better than lower case because their uniform shape and spatial relationships makes them easier to "convert back" to what we are used to. Once an authoritative tone of voice has been decided upon, it is reinforced by enlarging the word "WAR," placing it in a towering position above the other words and printing it in red. By letterspacing "BACKWARD" it acquires a little more emphasis than it would if left alone, and this prevents it from disappearing or seeming to be a mere afterthought. Next, the black background adds drama.

Below In further experimentation, the entire background is made black — with the right effect. The overall blackness now holds the statement together, and substantially increases the sense of drama. As a further refinement, the phrase "is backward" is softened slightly by the use of a gray tint on the letters.

The Result

The finished poster produced by Ruhi Hamid is shown here.

Barely visible abstract shapes, overprinted in clear varnish, give an understated impression of the smoke that is inescapable in warfare and puts the finishing touch to a strong and hard-hitting message achieved through the simple but carefully considered use of type.

Above Finally the size relationship of "WAR" and "is backward" must be carefully adjusted when transferring to the format of a large poster. "WAR" can now afford to grow much larger in size, particularly as the black background provides an anchoring effect for the whole statement (by holding it together)

Left Here is the typographic composition by Ruhi Hamid as it finally appeared in poster form. Two elements have been added. A red spear-like slash rises from the bottom of the poster, which emphasizes the opposing directional forces taking place within the composition ("WAR" reads left, and the rest of the statement reads right). This counterbalance effect is made even more evident by the linking of color (red). The second element appears in the form of barely visible abstract shapes, overprinted in clear varnish and symbolizing the smoke of aftermath and ruin.

We follow Project 4 with other examples of work that show the strong visual impact that can be achieved when type is the central design feature.

■ **Right** An invitation to an evening of Japanese cuisine, designed by Rubin Cordaro Design, 1983, which uses type to suggest the impeccable presentation of Japanese food.

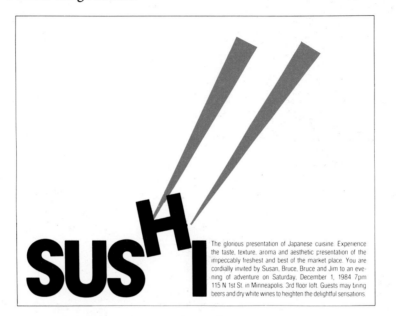

The glorious presentation of Japanese cuisine. Experience the taste, texture, aroma and aesthetic presentation of the impeccably freshest and best of the market place. You are cordially invited by Susan, Bruce, Bruce and Jim to an evening of adventure on Saturday, December 1, 1984 7pm 115 N 1st St. in Minneapolis. 3rd floor loft. Guests may bring beers and dry white wines to heighten the delightful sensations.

■ **Below** This poster was designed by Alan Fletcher of Pentagram for Daimler-Benz, the German automobile manufacturers, to celebrate the 100th anniversary of the birth of the car (1986). The design was also adopted as the motif for a series of events held by Daimler-Benz around the world.

100TH ANNIVERSARY OF THE AUTOMOBILE

■ **Above** Symbol for Cubic Metre Furniture, a furniture design and manufacturing company, by Minale Tattersfield & Partners.. An elegantly simple twist of letterforms creates a design that is both pertinent and memorable.

f22

22 Contemporary Women Photographers
An exhibition held by the Association of Fashion Advertising and Editorial Photographers 19th-30th January 1987
The Association Gallery, 9-10 Domingo Street, EC1 (off Old Street) Monday to Friday 9.30 am until 6.00 pm
Sponsored by Carlton T&S Limited and Carlton Studios Limited

■ **Left** Title with a double meaning: an f22 aperture reading on a camera is used here to represent 22 women photographers. The f22 (which appears in bright yellow in the original) pierces the empty blackness of the background, like bright light piercing darkness through the opening of a camera shutter. Poster designed by The Partners, for the Association of Fashion Advertising and Editorial Photographers, 1987.

■ **Right and below** Alan Fletcher of Pentagram created a symbol of a star for The Commercial Bank of Kuwait (1980), constructed on the Arabic words for "Commercial" and "Bank." The Kufic style of calligraphy enables the lettering to become a semi-abstract design, legible in content to an Arab and recognizable by pattern to a non-Arab. The symbol can therefore be "read" by Arabic speakers, while the star itself is considered highly significant in Islam. Our example shows the symbol itself, and a version in which the symbol is extended to form a chain, thereby creating a striking overall image. (Calligrapher: Jamil Majid.)

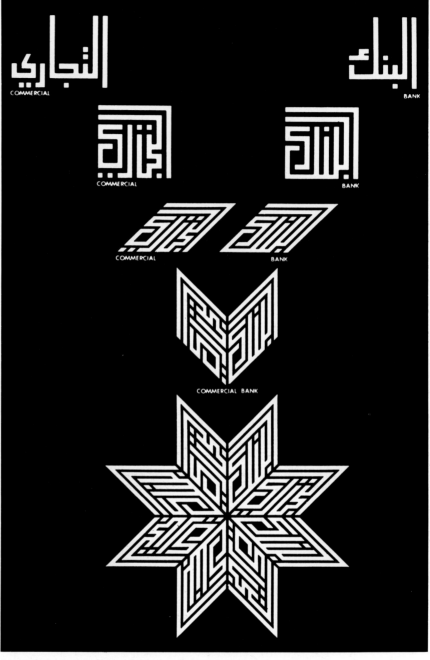

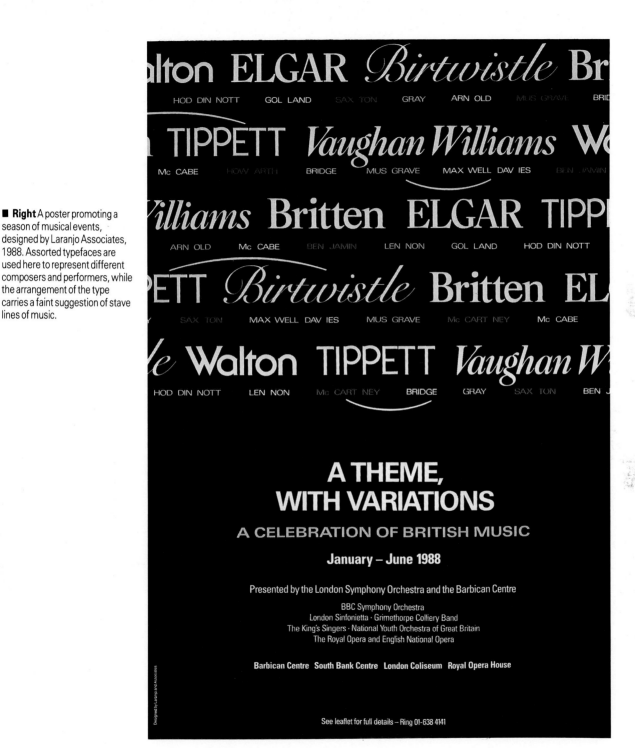

■ **Right** A poster promoting a season of musical events, designed by Laranjo Associates, 1988. Assorted typefaces are used here to represent different composers and performers, while the arrangement of the type carries a faint suggestion of stave lines of music.

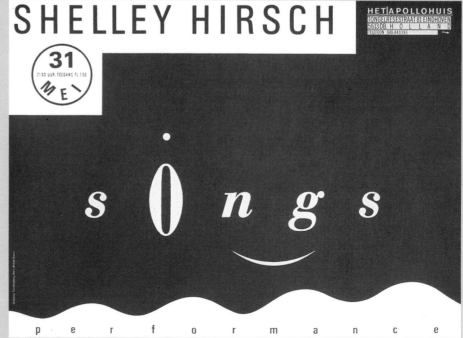

■ **Right and above** Two posters for musical performances in Eindhoven; designed by Hans Arnold and Ton Homburg of Studio Opera, Holland. Both use type to express musical qualities: one contrasts the rhythmic punch of percussion and the stateliness of cello; the other depicts the flow of a melody in wavy lines.

■ **Right** A Christmas card for (and by) Sutton Cooper design studio, which plays upon the old tale of The Emperor's New Clothes. In this version, the Emperor — a lover of books rather than clothes — is conned by the prospect of an invisible ink…Good fun, and a graceful design that expertly carries the tone of mock seriousness.

Many years ago, there was an Emperor, who was so excessively fond of new books that he spent all his money on them. He did not trouble himself in the least about his soldiers; nor did he care to go either to the theatre or the opera, except for the opportunities then afforded him to read the programmes. He had a different book for each hour of the day and a different library for each week of the year; and as of any other Emperor one is accustomed to saying, "He is reading State Papers", it was always to be said of him, "He is reading the latest Jeffrey Archer". Time passed by merrily in the large town which was his capital; strangers arrived every day at the court. One day two rogues, calling themselves weavers, made their appearance.

■ **Right** Subtlety and style shown in a logotype for Chrysalis Records designed by Peter Saville and Associates, 1987.

■ **Below** Logotype for London's Whitechapel Art Gallery by Peter Saville and Associates, 1985, which lends a classical feeling (but with clean, modern overtones) to the gallery's visual identity.

Chrysalis

WHITECHAPEL

TYPE & COLOR

PROJECT

**Choose one of the following words:
LOVE HATE CALM**

and by experimenting with different combinations of type and color produce at least two versions of that word, each conveying a different atmosphere and feeling.

Color + type = emotion!

Color plays many roles when combined with type (*see* "The Use of Color," pages 36-39). One of the most exciting and pleasurable design tasks lies in using it to conjure up feelings and emotions, to create mood and atmosphere.

Color is used in the art and entertainment worlds, in particular because it can exploit the whole range of human experience, from tragedy and despair to comedy and happiness.

Theater and movie posters offer splendid opportunities for large-scale emotion to be conveyed by color and type, just as book jackets, magazine covers and records do on a smaller scale. All need to make their impact fast and convey the right degree of emotion as well as accurate information.

This exercise allows you to experiment with the way that color and type can be used to influence the mood and meaning of a word. We demonstrate different treatments of the words love, hate and calm — and once you have absorbed the ways in which we have shown how color changes mood, you can enjoy yourself by trying out others. You will find that words describing human emotions are particularly good for this exercise and when you feel ready to try a more difficult one, we suggest you tackle "jealousy."

Above A feeling of temporary calm emanates from a pattern of dull gray squares, set within a stronger blue. The gray and the blue work together to create an atmosphere of potential excitement — as if activity has been placed on "hold" for a short time (a calm moment within a normally busy office, perhaps?). The scattering of letters throughout the squares adds to the subdued mood.

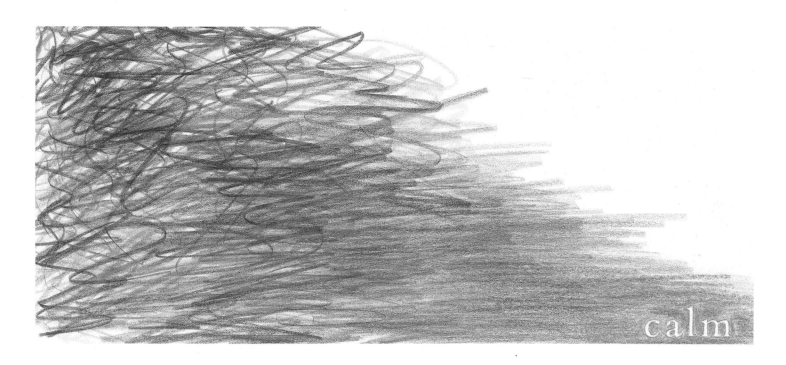

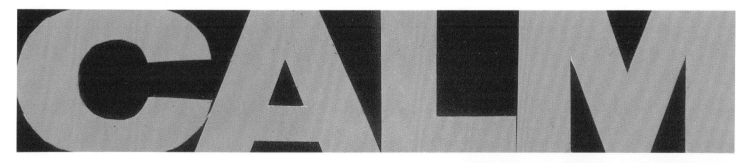

Top The frenzied, colorful scribbling of "noisy" excitement gives way to an even, gray calm, shown by thin type that is sitting quietly and comfortably in the lower right corner of the composition.

Above A rendition of calm — which isn't calm at all. This is an example of how color can be used to contradict a verbal statement, thereby delivering its message in a facetious tone.

Right A moody calm, conveyed by dark, warm colors suggestive of mystery and night. The thin weight of the type and the wide letterspacing provide a feeling of quiet stability.

Love is depicted here in a number of guises. Vibrant, overpowering passion is shown in red; romance is conveyed through the use of swirling, decorative type; chubby, pink letters communicate in a shy and gentle tone; and large, overlapping letters present a jumbled state of mind which fails to "read" or make sense (one of love's most common symptoms!).

These interpretations of the word "hate" make heavy use of black and red, as well as bold type, torn shapes and jagged edges, to create visions of anger and power.

Scattered and overlapping arrangements of type also introduce elements of ruination and destruction.

The following examples show how color and type can work together to convey emotion, atmosphere... and even a sense of the past.

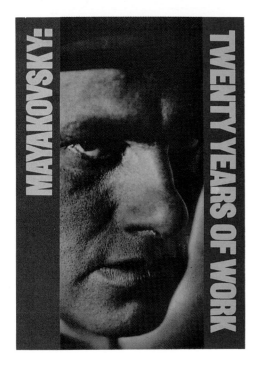

■ **Left** Paperback covers that relate to the world of fantasy and dreams. Notice how the use of color differs. Ian McEwan's short stories tend to deal with the disturbing, murky depths of human nature, and are portrayed with esoteric illustrations in misty blues and purples. Angela Carter's dream world, on the other hand, is more vivid and robust, and is suitably painted in warm orange and yellow hues.

■ **Right** Poster for the play *The Sleeping Beauty* by Daril Gregan, designed by Bob Linney of X3 Posters, London. A poster that communicates a world of fantasy, with the help of wild and wonderful handlettering. A cloud of sleeping z-z-z's emanate from a castle surrounded by a tangle of thorns — all set against a silkscreened background of melting colors.

■ **Left** Themes surrounding revolution or left-wing politics are often depicted in the heavy rules and uniform typefaces of Constructivism, or by use of high-contrast photography. In addition, the color red is almost certain to feature in images of revolution, as on the paperback covers here.

Amsterdam Belfast.

Belfast-Amsterdam direct.

BRITISH AIRWAYS
The world's favourite airline.

■ **Left** In this advertisement, color is used to isolate a phrase that can't help but bring a smile. Wisecracking humor in a poster created for British Airways by Saatchi & Saatchi.

■ **Above** Logotype (for the British Labour Party) which had a relatively short life; it was replaced by a logotype featuring a red rose. This is an interesting example of difficulties stemming from associations: although red is the accepted representative color of the Labour Party, the image of a red flag was considered too revolutionary in tone, and therefore gave way to the "safer" image of a red rose.

NATIONAL NO SMOKING DAY

Wednesday 9th March

Look after your HEART!

■ **Right** Poster by Jacqueline Casey of MIT Design Services, for The Shoshin Society. The solid strength of the type, and use of color to highlight "USA" from within the word "RUSSIA," provides symbolic expression of the important relationship existing between two super-powers.

■ **Left** Promotional material for National No Smoking Day, created by Abbott Mead Vickers/SMS for Britain's Health Education Council. The internationally recognized prohibition symbol of a red circle with a diagonal slash (in this case forbidding smoking) is incorporated into the typography in a simple and eye-catching design. There's no mistaking the message here — the red symbol can mean only one thing…DON'T.

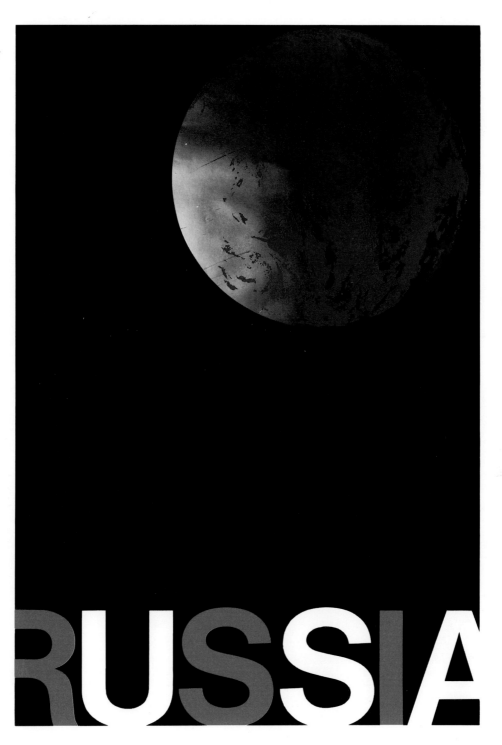

■ **Left** A series of music book covers which show type, image and color working together to re-create the flavor of a decade. For each decade, one song is shown playing on the period radio, and the rest of the objects in the room relate to the song title. The color schemes used in each case are also highly indicative of the time. Covers designed by Howard Brown and Peter Wood, London.

■ **Right** Part of a promotional campaign for Bloomingdale's department store in New York, by Tim Girvin Design Inc. Color and letterforms work together here to create an impression of sizzling heat waves. The design enhances the message, and the letterforms are beautifully offbeat in their construction.

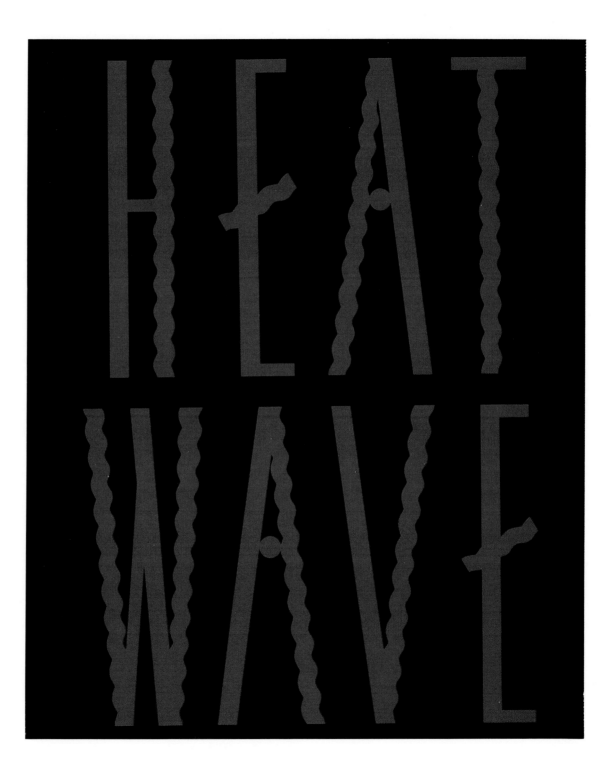

TYPE

& IMAGE

Look out for letters or numerals in your daily surroundings.

You will find this an excellent exercise in observation and association.

"Kurlansky Kaps": an alphabet produced by Mervyn Kurlansky of Pentagram, using found objects from around Pentagram's London studio — each a familiar item from the designer's world. Imposing a constant cap height resulted in a bizarre variety of scale across the twenty-six letters.

The promotional material for Grundy & Northedge Designers includes this wonderful rendition of their client list — completely composed of punctuation and miscellaneous signs from different type fonts.

Looking for letterforms

One way or another we are surrounded by letters and numerals. They may be on street signs or buses, on store-fronts or mailboxes, or fire hydrants or trash cans. Make yourself notice and analyze them. You can turn it into a light-hearted game or a time-consuming and difficult challenge; the exact form of the exercise is less important than what you learn from doing it.

Thinking about letterforms in common or unusual contexts makes us consider the associations surrounding words and letters, their relationship to each other and their accompanying images as a combined visual statement.

You can simply collect and record interesting examples.

You can look for objects or shapes in your surroundings that resemble particular letters.

You can hunt for objects that convey the meaning of a letter or numeral; for example a dozen eggs for the number 12.

Notice what difference it makes, if any, when one letter is missing from a word or has fallen loose from a signpost and hangs askew. Once you start to look at letterforms in this new way, you can start to experiment yourself. Why not try to compose your own from a specified set of elements, such as vegetables, or nuts and bolts, or alternatively compose shapes or images from letters? See the list of clients made up from punctuation marks by Grundy & Northedge shown here.

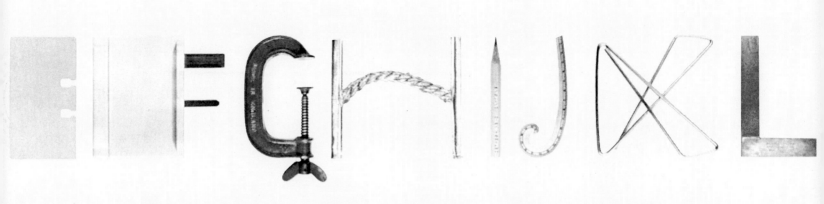

Richard Moon
**British
Council**

Martin Hazell
CDD

David Driver
Times

Ian Craig
**Jonathan
Cape**

Helen Auty
RSA

Mandy Brown
**Wolff
Olins**

In an exercise created for her own amusement, designer Liz McQuiston borrowed letters, numerals and punctuation from different typefaces and "doodled" a context around them — an enjoyable way to learn the identifiable characteristics of a typeface.

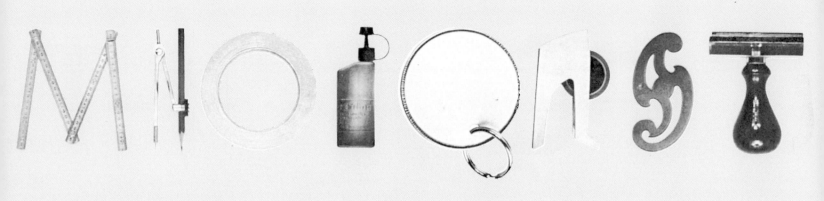

 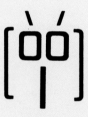

Angela Godwin
Imperial War Museum

Charles Lawrence
Lawrence Wrightson

Nichol Mutch
PSA

Stephen Povey
Diametric

Jackie Vickary
Michael Peters & Partners

Robert Warden
Design Centre Shop

 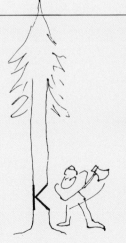

David Hurd
**Stately
Albion**

David Holmes
**Holmes Knight
Richie**

???
**Small Back
Room**

John Freeborn
**London Transport
Museum**

Douglas Wilson
**Conran Octopus
Books**

John Nash
**John Nash &
Friends**

Our commercial examples provide creative proof that graphic designers just cannot resist concocting bizarre alphabets, or collecting strange and wonderful examples of letterforms... and will jump at any opportunity to do so in a commercial job.

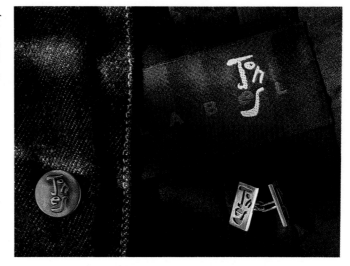

■ **Right and above** Corporate identity for Jones clothing stores, by Autograph Design Partnership. The logotype is composed of freely-drawn letters, assembled to form a face. It's not only fun, but also relates to the idea that we project our personality and image through our clothing. The identity is shown here applied to shopping bags, buttons, clothing labels, and an illuminated sign.

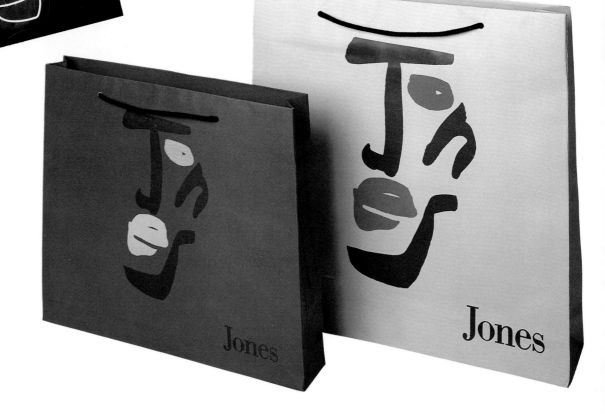

Right A poster calendar designed by Minoru Morita for his exhibition in New York and Tokyo, 1984. The 365 days of the year are represented by photographs of street address numbers — a display of the interesting diversity of New York City.

Below A combination of engraved images creates the logotype of the Images design studio in Louisville, Kentucky. It is shown here on an envelope from their stationery range.

■ **Right** Poster for the exhibition "British Painting '74," by Alan Fletcher of Pentagram for the Arts Council of Great Britain. The lettering of the title embodies the creative spirit of painting, and the illegible quality of some of the letters adds significantly to the mood of freedom and excitement.

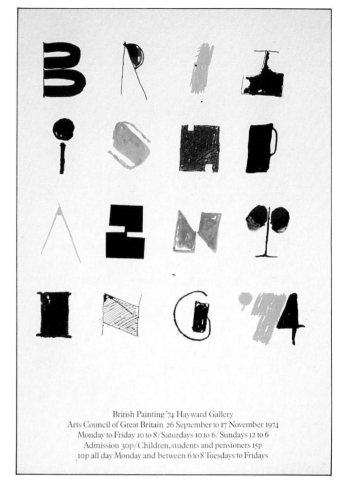

British Painting '74 Hayward Gallery
Arts Council of Great Britain 26 September to 17 November 1974
Monday to Friday 10 to 8/Saturdays 10 to 6/Sundays 12 to 6
Admission 30p/Children, students and pensioners 15p
10p all day Monday and between 6 to 8 Tuesdays to Fridays

■ **Right and below** a design by Darrell Ireland which promotes the Color Presentation Service offered by Alphabet typesetters. Each letter is taken from the symbol/logo of a well-known company or product, and all combine to spell out the client's name — Alphabet. It's impossible to resist the temptation of trying to cite the origin of each letter…

A: Access credit cards L: Libby's foods P: Pirelli tyres H: Harrods department store

Right In this cover for *The Listener* magazine, illustrator Peter Brookes has produced a wonderfully bizarre group of letters derived from a most unlikely source — medical equipment.

THE LISTENER

6 November 1980 Price forty pence (USA and Canada $1.20)

Ian Kennedy
The rhetoric of medicine

Keith Kyle
Poland's fight for freedom

Phillip Whitehead
The American Presidency

Robert Hughes
Pop art's inventors

Daniel Snowman
Sex and gender

Andrew Sinclair
Potter's TV trilogy

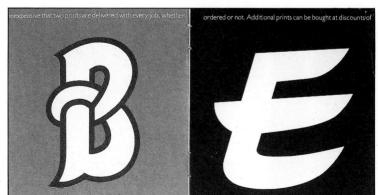

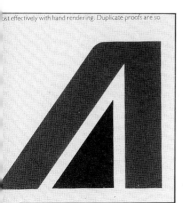

ost effectively with hand rendering. Duplicate proofs are so

inexpensive that two prints are delivered with every job, whether

ordered or not. Additional prints can be bought at discounts of

up to 90%, *if asked for at the time of the original order.*

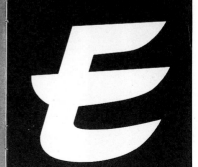

A: Alitalia airline

B: Bisto foods

E: Express Dairy products

T: Tate & Lyle sugar

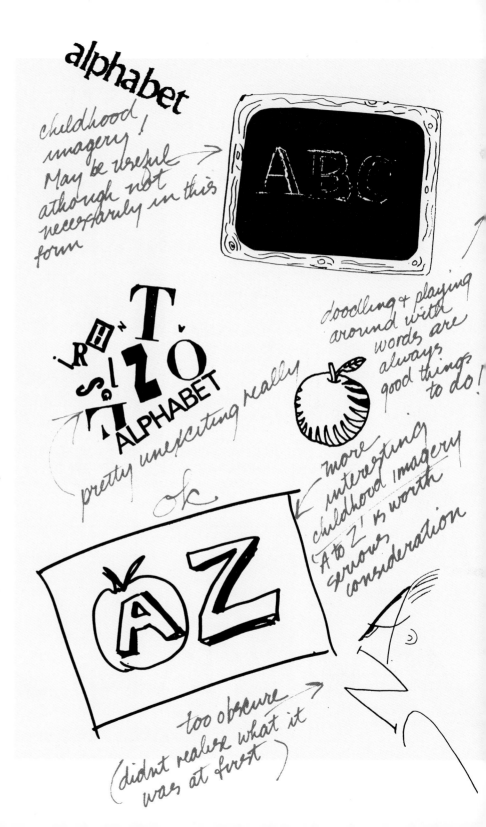

PROJECT

Design a logotype/ symbol for a typesetting firm named "Alphabet."

The development of this project is concerned with the interplay of type and image.

Stage One

This project was in fact a commercial brief undertaken by designer Darrell Ireland.

Brainstorming ideas for a logotype for a firm called "Alphabet" typesetters is bound to start by thinking of combining different typefaces within the word "alphabet," or recalling our early schooldays when learning to read. So to avoid being obvious during the brainstorming session, you must be more than usually aware of your critical resources in order to develop a fresh approach.

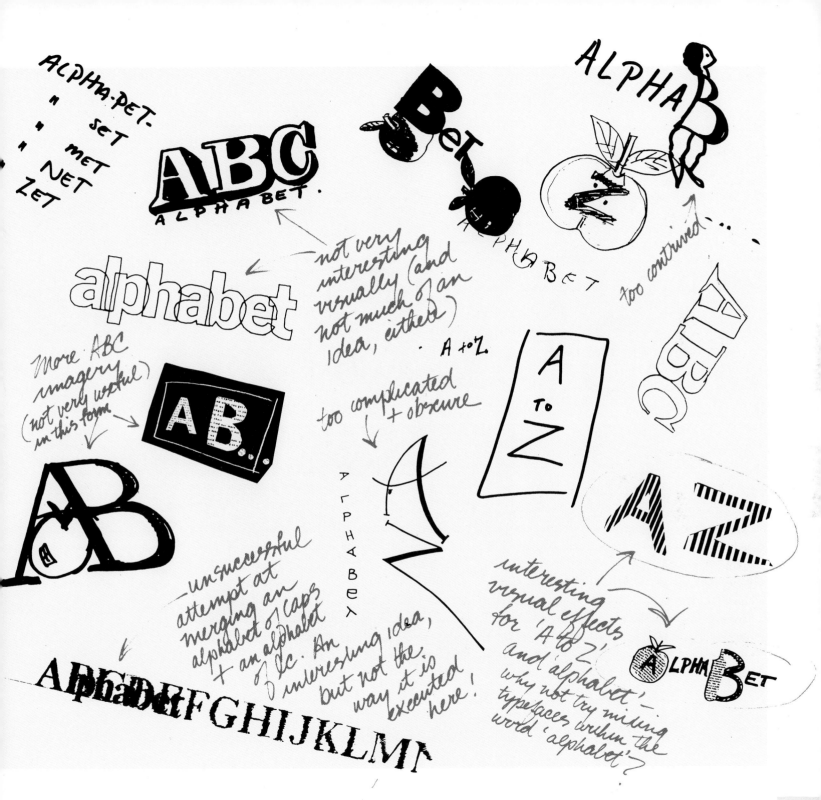

ALPHA·PET·
" SET
" MET
" NET
ZET

ABC
ALPHABET.

Bet
ALPHABET

ALPHA
Bet
ALPHABET too contrived...

alphabet

not very interesting visually (and not much of an idea, either)

A to Z

too complicated + obscure

More ABC imagery (not very useful in this form)

AB.

AB

ABC

A to Z

AZ

A
L
P
H
A
B
E
T

Z

unsuccessful attempt at merging an alphabet of caps + an alphabet of lc. An interesting idea, but not the way it is executed here!

interesting visual effects for 'A to Z' and 'alphabet' — why not try mixing typefaces within the word 'alphabet'?

ALphaBet

ABCDEFGHIJKLMN

Below As a result of the brainstorming session, two distinct approaches emerge. The first approach is represented by the group of roughs shown on this page — all of which are variations based on the mixing of typefaces within the word "Alphabet." The roughs, as a group, possess interesting visual qualities. But no single rough has the potential to develop into a memorable visual image. In fact, once the novelty of their peculiar appearance has worn off, they all begin to look surprisingly similar! Further development is unlikely to turn any member of this group into a unique visual statement.

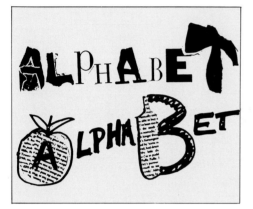 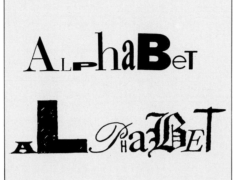

Stage Two

We next demonstrate the dilemma which arises when faced with having to choose between two diametrically opposed approaches. The roughs singled out in the boxes above represent an all-too-obvious idea, but one which could be developed in an interesting way visually. For example, an exotic mix of typefaces could be used but might lose their point if one could not be sufficiently distinguished from another or if color cannot be called in to help. Mixing typefaces and type sizes, a pretty common technique anyway, will hardly produce a lasting visual impact.

The group of roughs on the right (adjacent page) offers more scope. They are variations on "A to Z," a phrase which is commonly understood as meaning "the alphabet." An intriguing option appears: the expression of "A to Z" without the use of letterforms — but with images that we all remember and enjoy from childhood picturebooks. It also offers a highly memorable image, and so this direction is the one that is pursued.

Right The second approach, shown by the set of roughs on the next page, is based around the expression "A to Z." This approach offers greater scope — not only with regard to the visual appearance of the letters, but also in terms of associations with the phrase itself. "A to Z" conjures up memories of schooling and childhood imagery related to learning the alphabet…such as "A is for Apple" and "Z is for Zebra."

A ——————————— to ——————————— Z

A Apple, a

is a Zebra

Left and above A variety of typefaces and letterforms is considered in this assortment of "A to Z" roughs and some interesting results appear. But by far the most intriguing version is produced by replacing the "A" with an apple and the "Z" with a zebra. The phrase "A to Z" is no longer *read*, but is now *implied*…and the message is still clearly understood. In addition, the impact of the image fares very well in comparison with other images on the page — and so this version is chosen for further development in Stage Three.

Below In this progression of sketches, the apple and zebra image undergoes a number of changes. The freely-drawn images are too "fussy" in appearance, and are replaced by rigidly drawn, hard-edged images. Both are then converted to a similar style, so that they read as one symbol. The word "to," a hangover from the former "A to Z" rough, is a disruptive element in this version — so it is eliminated.

Is the word "to" really necessary?

Since the two images of apple and zebra make a simple, clear point *without* the use of words, "to" adds nothing to the design or comprehension and can, and should, be eliminated.

Stage Three

A number of further decisions have to be made in developing the apple/zebra image.

Should the images be free-flowing or constrained in appearance?

A hand-drawn rendition in this context would make the images unnecessarily fussy, and if we want to play upon those childhood memories of picturebooks and alphabet blocks we will opt for a more mechanical set of images.

Should the apple and zebra images both have the same visual character?

It will be clear from the progression in the sketches above that it is important for both images to have the same visual character. When standing together, side by side, they represent one idea — and they should be read as one thought, or one statement.

What about boxing them?

The images are sufficiently strong to stand well on their own, so boxing them would only serve as an affectation or "fussiness" and be unhelpful to the communication of the idea, creating a rigidity that would be displeasing.

Should the image be accompanied by the name of the firm?

Although the images provide a strong identity for the firm of typesetters, they cannot substitute for the company name, so it should be incorporated in the design.

Left and right Having removed the word "to," the visual statement now seems to lack something. Various attempts are made to box the images, or produce them as reversals (white on black), but this only interferes with the impact of the imagery. What is missing, in fact, is a supportive element of type, which ties the symbol to the company name. The name is shown here in a number of typefaces and positions. Because of the thin line quality of the images, a thin uniform sans serif typeface appears most complementary, and provides a suitable base for the images when positioned beneath them.

Below The use of color (in reality the apple is bright green) lends a bit of "punch" to the imagery, and the type is adjusted in size and positioning. Also, capitals are introduced, since they provide a more stable visual base for the images to stand on.

Below Logotype for Alphabet typesetters, designed by Darrell Ireland, London.

The Result

The final logotype produced by Darrell Ireland for Alphabet typesetters is shown here in its rightful place on stationery. We also show how the logotype idea was extended and applied to other items such as the covers of type specimen books and notepads. It's ingenious and fun, provides a memorable identity for the firm, and stands as an excellent example of how words can give way to an image, or vice versa, when exploring new and different ways of communicating a message.

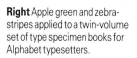

Right Apple green and zebra-stripes applied to a twin-volume set of type specimen books for Alphabet typesetters.

Below Logotype/identity for Alphabet typesetters, designed by Darrell Ireland, London. (In reality, the apple of the logo is colored a vivid green.) The logotype is shown here applied to letterheaded stationery, as well as a summertime promotional brochure (left and below). The notepad "blocks" at the bottom of the page show extension of the identity through abstract elements: one of the blocks is apple green, the other is covered by a zebra-striped pattern. The covers of Alphabet's twin-volume type specimen books (bottom of previous page) sport the same theme: one book cover is green, and the other zebra-striped. The identity is unmistakable, and easily spotted amid the chaos of a busy design studio.

Left Notepad "blocks" for Alphabet typesetters, showing the application of apple green and zebra-stripes.

The interplay of type and images is displayed in the many examples that follow, showing type and image working together, type substituting for images, and images substituting for type...

■ Right Advertisements for Danish Bacon, which make use of the brand name "Danish" (stamped on the meat) to create copylines such as "fresher," "leaner," etc. Designed by Wight Collins Rutherford Scott & Partners, London.

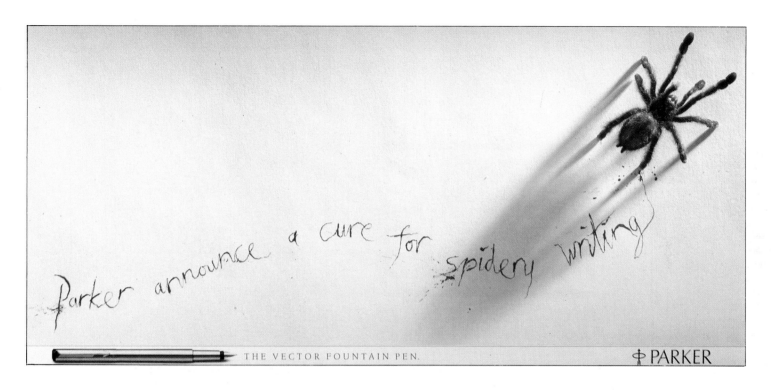

Parker announce a cure for spidery writing

THE VECTOR FOUNTAIN PEN. ⟡ PARKER

MIDDLE TAR As defined by H.M.Government
DANGER: Government Health WARNING: CIGARETTES CAN SERIOUSLY DAMAGE YOUR HEALTH

■ **Above** Handwriting poses as spider-writing in a poster that promises to rid us of ink blobs and mess, if only we buy a Parker pen. Created by Sutton Cooper design studio.

■ **Left** Advertisement displaying Benson and Hedges cigarettes: one of a long series renowned for artful communication without a copyline. The imagery says it all — and it has to, to conform with laws controlling cigarette advertising.

■ **Right** Poster designed by
Richard Bird and Associates for
the National Theatre production of
The Rivals, a play by Richard
Brinsley Sheridan. A short title
becomes a memorable visual
emblem, due to the substitution
of guns for the "V" in "Rivals."

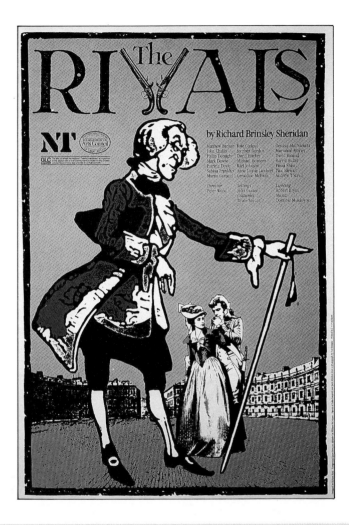

■ **Right** Chinese characters are
substituted for Roman letters in
this logotype for the Hong Kong
Trade Fair designed by Lora
Starling of Starling Design,
London.

■ **Right** The old saying "Heard it
on the grapevine" is put to good
use in a card design by Darrell
Ireland that mixes type and
images to announce his move to a
new office location.

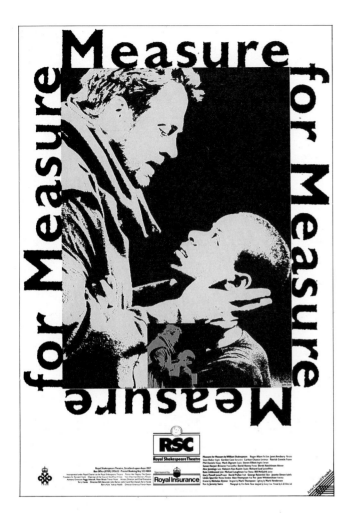

■ **Left** Poster for a production of Shakespeare's *Measure for Measure*, designed by Ginny Crow for the Royal Shakespeare Company in 1987. An interesting merging of type and image: high contrast photography is framed by type that has acquired a "stubbled" effect due to photographic enlargement. The two complement each other with their "roughness."

■ **Left** This paperback cover for *The Penguin Encyclopedia of Chess* shows the substitution of a chess piece for an "S." A restrained and sophisticated design by David Pearce and Associates, London.

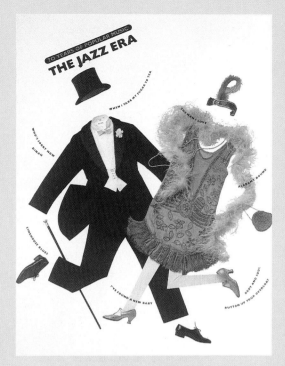

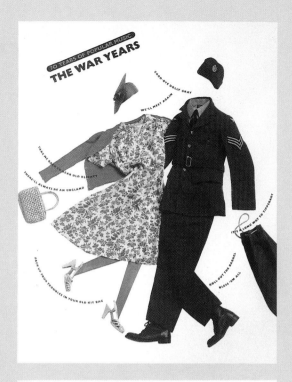

■ Right Cover designs by Howard Brown and Peter Wood for a series of songbooks intended to capture the mood of specific periods in the history of popular music. They present a marvelous example of the interplay between type and image. The images are clothing props culled from each period; the type consists of relevant song titles, arranged so that they swing around the imaginary dancing couples and create a feeling of movement.

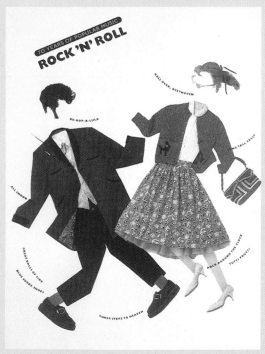

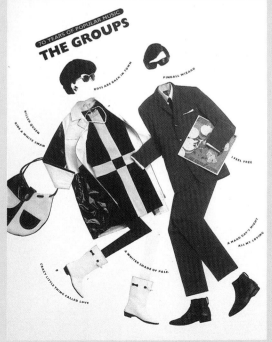

■ **Left** In this 1985 calendar by London design group Sutton Cooper, type provides a backdrop for illustrations on the theme of "fakes." The month of February (top) carries an illustration by Lynda Gray, depicting the use of fake Roman marble-top vinyl. The month of July (bottom) is a scattering of fishing flies — illustrated by Glynn Boyd Harts — which are, of course, fake flies. Although the type plays a secondary role to the imagery, it is not handled as a boring or forgotten element. The arrangement and coloring are complementary to the images and provide background interest.

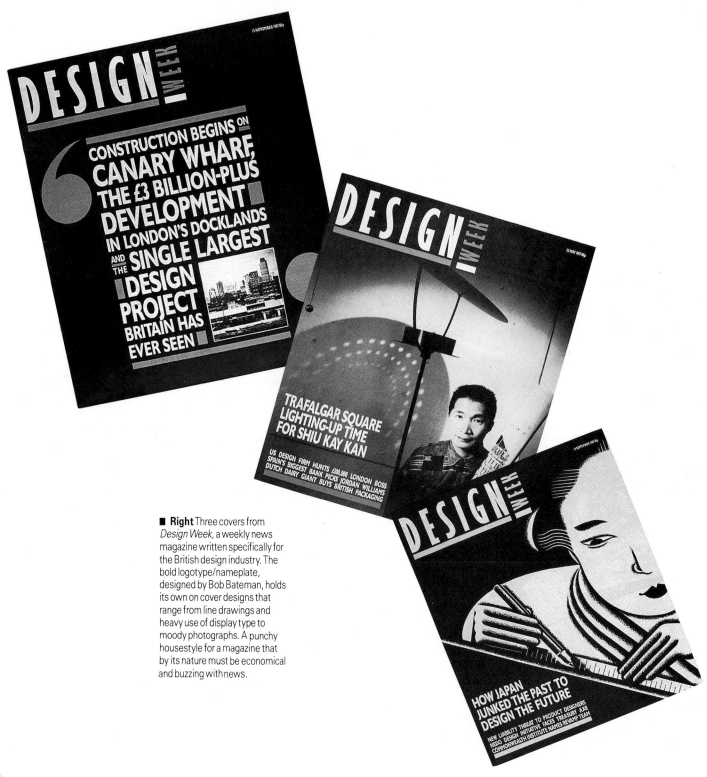

Right Three covers from *Design Week*, a weekly news magazine written specifically for the British design industry. The bold logotype/nameplate, designed by Bob Bateman, holds its own on cover designs that range from line drawings and heavy use of display type to moody photographs. A punchy housestyle for a magazine that by its nature must be economical and buzzing with news.

■ **Left** Sleeve for the album entitled *Low-life* by the music group New Order. The design, by Peter Saville and Associates, uses overprinting of type to create a simple but distinctive design feature (1985).

■ **Above and left** The recent re-design of the London newspaper *The Guardian*, by David Hillman of Pentagram. The nameplate employs two typefaces in a style that is carried onto the center section (which changes its heading from day to day). The faces appearing above the nameplate create an image that promises popular topics and human interest.

Final thoughts

Our approach to the creative use of type has centered on a number of key "themes" or principles — for example, developing a love of letterforms, interpreting the meaning of words through the manipulation of type, using color to enhance (or even contradict) a verbal message. The project exercises contained in Part Three aimed to bring these issues to our attention; the projects then put these principles to work in a professional context. Commercial examples shown at the end of each project served to broaden the discussion to include a variety of work by other designers.

However, the projects and exercises can only outline the *basis* for a creative approach. When all is said and done, it is up to the individual designer to build on that foundation and develop a personalized method of working with type, and a personal approach to design problems. As stated earlier, a keen sense of observation — strengthened by visual research — is an important asset, as well as a lively sense of experimentation. But the most important quality to be gained is sensitivity — to language, typefaces, type arrangements, space, color, and all the other design elements discussed in this book. The best, the most enjoyable, and indeed the only way to achieve this is through practice, determination, and personal exploration.

Index

Acknowledgements

p10 *top,* Fernando Medina, Montreal; *bottom left,* Peter Saville & Associates, London: Art Director Peter Saville: Typographer Brett Wickens; *top left,* Tim Girvin Inc. Seattle, Washington. **pp10-11** Fernando Medina, Montreal. **p11** Richard Bird & Associates, London. **pp12-13** Henning Marks. **p18** Christine Barrow. **p19** Studio Dumbar, Holland. **p21** *left,* Creative Center: New York, NY: Minoru Morita. **p22** Images, Louisville, Kentucky: Julius Friedman & Walter McCord. **p23** Pentagram Design Limited, London. **p24** Grove Press. **p25** Emerson Wajdowicz Studios Inc, New York, NY: Art Director Jurek Wajdowicz. **p26** *bottom left,* Total Design, Holland, *right,* Peter Saville & Associates, London: Art Director Peter Saville: Typographers Peter Saville & Brett Wickens: Photographer Trevor Key. **p27** Gregory Cutshaw, Dayton, Ohio. **p28** *bottom left,* Abbot Mead Vickers, SMS Ltd, London; *top right,* Autograph Design Partnership, London. **p29** *left,* Pentagram Design Limited, London; *center and right,* Saatchi & Saatchi, London. **p30** Dave King/Museum of Modern Art, Oxford; **p31** *bottom left,* Hans Arnold; *top right,* Saatchi & Saatchi, London. **p32** Saatchi & Saatchi, London. **p33** *top left,* Pentagram Limited, London; *bottom right,* Sullivan Perkins, Dallas, Texas: Designer Willie Baronet: Art Director Ron Sullivan: Writer Mark Perkins: Photographer Geof Kern. **p34** *top,* Howard Brown & John Gorham, London; *bottom,* Ogilvy & Mather, London. **p35** *top,* Holmes Knight Ritchie/WRG, London; *bottom,* Pentagram Design Limited, London. **p36** *bottom left,* London Underground. **p37** *top,* Elle, *bottom right,* Post Office. **p38** *top left,* i-D magazine; *bottom right,* Island Records. **p39** *top,* London underground; *bottom right,* X3 Posters, London: Ken Meharg. **p40** *bottom left,* Autograph Design Partnership; *right,* Leagas Delaney, London. **p41** *top left,* The Partners, London; *top right,* Studio Opera, Holland; Ton Homburg & Barry van Gerwen; *bottom right,* Tim Girvin Design, Seattle, Washington. **p44** *top left,* Prins Koeller, Chicago, Illinois: Patrick Koeller; *top right,* Grundy & Northedge, London; *center,* Pentagram Design Limited, London; *bottom,* Howard Brown, London. **p45** Studio Dumbar, Holland. **pp54-57** Christine Barrow & Steve Hollingshead. **p58** *top center,* Michael Wolff/Wollf Olins, London; *left,* Grundy & Northedge, London; *bottom right;* Autograph Design Partnership. **p59** The Small Back Room, London. **p60** *top and bottom left,* Fernando Medina, Montreal; *bottom center left,* Sibley/Peteet Design Ltd: Paul Black; *bottom center right,* Eisenberg Inc., Dallas, Texas: Don Arday; *bottom right,* Christine Barrow, London. **p61** Grundy & Northedge, London: Peter Grundy. **p62** Studio Opera, Holland: Jan Bolle & Barry van Gerwen. **p63** *top,* Studio Opera: Hans Arnold & Ton Homburg; *bottom left and right,* Pentagram Design Limited, London. **pp64-67** Christine Barrow & Steve Hollingshead. **p68** *top right,* Minale Tattersfield & Partners, London; *bottom,* Howard Brown, London. **p69** Studio Dumbar, Holland. **p70** *top,* Marketing Communications, Inc., Toledo, Ohio: Jeff Kimble; *center,* Grundy & Northedge; *bottom,* Paul Huber. **p71** *top,* Richard Brock Miller Mitchell and Associates, Dallas, Texas: Ken Shafer; *bottom,* Chetwynd Haddons Advertising Agency: Stewart Howard. **p71** *top,* Liz McQuiston, London; *bottom,* Samata Associates, Dundee, Illinois: Pat & Greg Samata. **p73** Paul Huber. **pp75-79** Christine Barrow & Steve Hollingshead. **p80** Fernando Medina, Montreal. **p81** *center left,* Autograph Design Partnership, London; *center,* Fernando Medina; *right,* Minale Tattersfield & Partners, London; *bottom,* Pentagram Design Limited, London. **p82** The Partners, London. **p83** Minale Tattersfield & Partners, London. **p84** Landor Associates, San Francisco, California. **p85** *top and center,* The Partners, London; *bottom right,* Howard Brown London. **pp86-87** Darrell Ireland, London. **pp88-94** Christine Barrow & Steve Hollingshead. **p95** Ruhi Hamid, London. **p96** *top,* Rubin Cordaro; *center,* Minale Tattersfield & Partners Ltd, London; *bottom,* Pentagram Design Limited, London. **p97** The Partners, London. **p98** Pentagram Design Limited, London. **p99** Laranjo & Associates, London. **p100** Studio Opera, Holland; Hans Arnold & Ton Homburg. **p101** *top,* Sutton Cooper, London; *center,* Peter Saville & Associates, London: Art Director Peter Saville: Typographers Brett Wickens & Chris Mathan; *bottom,* Peter Saville & Associates, London: Art Director Peter Saville: Typographer Brett Wickens. **pp106-107** Christine Barrow & Steve Hollingshead. **p109** *top,* Pan/Picador; *center,* X3 Posters, London: Bob Linney; *bottom,* Alison & Busby, London, Museum of Modern Art, Oxford: Dave King. **p110** *top,* Saatchi & Saatchi, London; *bottom,* Labour Party. **p111** *top,* MIT Design Service, Cambridge, Massachusetts: Design Jacqueline S Casey: Client Shoshin Society; *bottom,* Abbott Mead Vickers/SMS, London. **p113** *top,* Howard Brown & Peter Wood, London; *bottom,* Tim Girvin Design Inc., Seattle, Washington. **pp117-119** *center,* Grundy & Northedge, London; *bottom,* Liz McQuiston, London. **p120** Autograph Design Partnership, London. **p121** *top,* Creative Center, New York, N.Y.: Minoru Morita; *bottom,* Images, Louisville, Kentucky: Julius Friedman & Walter McCord. **p122** *top,* Pentagram Design Limited, London; *center and bottom,* Darrell Ireland, London. **p123** *top,* Peter Brookes, London; *bottom,* Darrell Ireland, London. **pp124-129** Christine Barrow & Steve Hollingshead. **pp130-131** Darrell Ireland, London. **p132** Wight Collins Rutherford Scott & Partners, London: Art Director Steve Grimes: Copy Writer John Bowman: Typographer Keith MacKenzy. **p133** *top,* Sutton Cooper, London; *bottom,* Collett, Dickenson, Pearce and Partners Ltd. **p134** *right,* Richard Bird & Associates, London: Designer Richard Bird: Foreground figures from an alphabet by William Nicholson: Photographer Zoe Dominic; *center,* Starling Design, London: Lora Starling; *bottom,* Darrell Ireland, London. **p135** *top,* Royal Shakespeare Company: Designer Ginny Crow: Photographer Clive Barda; *bottom,* Tatham Pearce Ltd, London: David Pearce. **p136** Howard Brown & Peter Wood, London. **p137** Sutton Cooper, London. **p138** Design Week. **p139** *top,* Peter Saville & Associates, London: Art Director/Typographer Peter Saville: Photographer Trevor Key; *center and bottom,* The Guardian.

reactionary as a determining factor or
reason foundation & within activity area.

Absorbtion of initially reactionary work into
the system — its proliferation and final
death through acceptance. INERTIA.

growing reactionism — Absorbtion — Calcifica
volitile potential. Acceptance Inerti

Wittgenstein - Tract. 6.54. 'My propositions serv
as elucidations in the following way; anyone wh
understands me eventually recognises them as
nonsensical, when he as used them — as steps.
to climb up beyond them. (He must, so to spe
throw away the ladder after he has climbed
it) He must transcend these propositions, a
then he will see the world aright'

Palatable reactionism —

If the system Accepts the work by recognit
and accepts it on account of its being reacti
hen it is in fact proving that it is not at
reactionary. A truly reactionary stance
yainst an existing system cannot possi
w absorbed by that system. The trull